NEW YORK REVIEW BOOK
CLASSICS

GUSTON IN TIME

ROSS FELD (1947–2001) was born in Brooklyn, New York;
attended Erasmus Hall High School; and did not quite
graduate from the City College of New York. From an early
age, he showed a gift for befriending artists and writers. In his
teens, he exchanged letters with Denise Levertov and took part
in the Poetry Project at St. Mark's Church-in-the-Bowery,
getting to know Paul Blackburn, Joel Oppenheimer, Frank
O'Hara, and Scymour Krim. In his early twenties, Feld worked
for Time-Life Books and, under Gilbert Sorrentino, at Grove
Press. After publishing one collection of poetry, *Plum Poems*
(1971), he devoted his considerable energies to prose. Between
1973 and 1999, he published four novels—*Years Out*, *Only
Shorter*, *Shapes Mistaken*, *Zwilling's Dream*—and countless
essays and reviews. It was Feld's review of a controversial show
by Philip Guston in 1976 that struck the first spark of their
friendship, which would continue until Guston's death in
1980. Feld died in Cincinnati after a long struggle with
lymphatic cancer, under whose shadow he had been living for
nearly thirty years.

GUSTON IN TIME

Remembering Philip Guston

ROSS FELD

NEW YORK REVIEW BOOKS

New York

THIS IS A NEW YORK REVIEW BOOK
PUBLISHED BY THE NEW YORK REVIEW OF BOOKS
435 Hudson Street, New York, NY 10014
www.nyrb.com

Grateful acknowledgment is made to the Estate of Philip Guston for permission
to include letters written by Philip Guston and for the reproduction of works of
art by Philip Guston in this book.

First published as a New York Review Books Classic in 2022.

Library of Congress Cataloging-in-Publication Data
Names: Feld, Ross, 1947–2001, author.
Title: Guston in time / by Ross Feld.
Description: New York: New York Review Books, [2022] | Series: New York
 Review Books Classics
Identifiers: LCCN 2021038740 (print) | LCCN 2021038741 (ebook) |
 ISBN 9781681376615 (paperback) | ISBN 9781681376622 (ebook)
Subjects: LCSH: Guston, Philip, 1913–1980—Criticism and interpretation.
Classification: LCC ND237.G8 F45 2021 (print) | LCC ND237.G8 (ebook) |
 DDC 759.13—dc23
LC record available at https://lccn.loc.gov/2021038740
LC ebook record available at https://lccn.loc.gov/2021038741

ISBN 978-1-68137-661-5
Available as an electronic book; ISBN 978-1-68137-662-2

Printed in the United States of America on acid-free paper.
10 9 8 7 6 5 4 3 2 1

CONTENTS

GUSTON IN TIME

LETTER

N O W *it is a different sort of contest—not what you saw—
not what you—we—talked about. Now the contest is between
knowing and not knowing. Since you were here—a week ago?—
I've painted three pictures—the first—a brick wall, me & Musa
behind it. In* <u>front</u> *of the wall, a sort of scrimmage is taking
place—arms, discs, etc., the abstract forces are trying to pile
themselves up into a permanent mound—BUT—a hammer
looming in from the top-side is definitely hitting this structure,
making it seem as if it is crumbling, collapsing. Added to all of
this, and below my profile and Musa's frontal view, is a fluttering,
a merry mix-up of buzzing insects—bugs—demon bugs—a
happy commotion. They, too, seem to be adding (I know they are)
to the general dismantling of the piled-up structure. It is a painting
of crumbling—of dissolution. As I look at it now—today—I was
heading for another state of feeling not known to me.*

The second picture is of me talking and smoking in a vast blue-gray but dense atmosphere. I am talking feverishly—there is a big pileup of cigarette butts plastered right smack on my cheek—and they form—God knows what—some sort of thick cluster of stuff, which moves in a sort of radial-like movement—in—out—and across (BUT THEY ARE STUCK!). I started to shake when I painted this picture. God, there <u>is no</u> picture plane! It is just real, that's all there is—just real—no plane at all—What nonsense—this idea of a plane—No—all there finally is left is just the moment—the second—of life's gesture—fixed forever—in an image—there—to be seen. (You could put your hand right into the image!)

Everything else is only a notion—a cluster of notions about art, just programming you might say. Well, this smoking talking man set me on my ear—I couldn't wait to start on the next. I decided to do a large one—on the wall this time. It is Thursday—the day you were here a week ago—and I have painted a large—large—cluster of people—beings, in a flood of closeness—there is no picture plane now whatsoever—There is now instead every mood—from anger—to sorrow—to peace—to resignation—to awe—to stillness—no movement, no diagram at all of held ideas—it is a mound of flesh, of eyes, cheeks, ears, bones, craniums—you could run your hand over it all, go into the narrow spaces between the heads, but there wouldn't be much room at all. A feather might barely get in. There is no order especially—if there is an order to it at all, I don't know it—don't comprehend it—it is like nothing I've done before—not

one area in this mound stops to let you look at it. Ah, so that's what "art" is—lets you stop—isolate it—lets us "see" it—but here in this new picture there is "nothing" to see—except multitudes of masses, that go on forever—in the mind. There is no plane—at all. You could mingle with this crowd, move into it—submerge yourself in it—be part of it. You would hear voices, murmurs, weeping—

[1978]

1. ALLEGORY

Philip Guston had a nearly limitless appetite for talk. Once, when I visited him upstate, the first words out of his mouth as he met me on the train platform at Rhinecliff were: "So—about Brancusi . . ." It wasn't surprising, then, to hear him begin telling me one day over lunch in the Village in 1977 about something he'd been reading a few days before that had excited him greatly.

He'd read an essay by Charles Rosen that had appeared in *The New York Review of Books,* a piece that concerned Walter Benjamin's 1928 book, *The Origins of German Tragic Drama.* This had been Benjamin's first and only completed longer work, his doctoral thesis (though rejected); and Rosen's discussion of one of Benjamin's signature ideas there—the notion of art as ruin— seemed to have enveloped Guston in a blaze of sparks. The

enthusiasm, coming from a painter whose father had for a time peddled junk—and who himself for forty years had been picturing garbage cans, middens, old pots, and crumbling walls—was understandable. Yet on that 1977 midday Guston seemed to me unusually wound up. His talk leapfrogged here and there. When we hadn't seen each other for a few weeks I tended to be more conversationally correct, spending some time tugging Guston back to earth a little when his kite seemed headed for a tree. But this idea of art as *finished* not only in a practical, immediate sense but in an elongatedly temporal sense—as something dead and in its very essence decaying—was something Guston clearly responded to on the deepest level, and there was no stopping him.

Not that many months later Guston would bring up Benjamin again, this time at a public "discussion" the two of us had together at Boston University. Guston was a University Professor there during the seventies, an appointment which involved periodic sessions of studio-teaching (he'd travel north from home and take a hotel room for the week) plus an every-now-and-then public talk. Guston preferred these talks to take the form of dialogues, and in the past he'd held one such with Harold Rosenberg and one other with his B.U. painter-colleague Joseph Ablow.

Guston and I were seated on a stage in the auditorium of the university's Law School. A table had been set up right in front of an imposing judge's bench used for moot court, and Guston started off by saying that it looked like the two of us were simply going to have to humbly *schmooze,* to counteract the pretentious public thing we were doing in such beetling surroundings. So we

duly schmoozed. Not fifteen minutes into it, Guston again was back on the Benjamin book, this time recommending as "very very interesting" Benjamin's analysis of Baroque allegory as outlined in the Rosen essay.

Guston then went on to refer to his own current paintings as allegories, which made me cringe a little. An unusually articulate man, he was hardly someone to use words he didn't mean—but allegory? So transpositional. So obvious. Besides, modernity had effectively neutered the whole category.

Guston patiently granted that allegory was, yes, all that, unmodern and certainly obvious. But then, with a small mischievous smile, he said: "That's why I think I like the whole idea." And more than simply liking it, he reminded me, he also had lately gone ahead and happily *used* the armature. For what else would I call a painting such as one he'd done a year before, *Pit* (1976)—a sulfurous sinkhole in Hades abrim with the heads of the grossly (and yet somehow happily) damned—other than an allegory?

I still wasn't convinced. Neither was Joseph Ablow, who was in the audience that night. Between us we came up with lots of reasons why allegory was merely a curiosity, why Guston's interest in the subject was somewhat perverse.

Guston was good-naturedly unmoved by all of this. "Well, I still think I'm making allegories."

Guston never did read Benjamin's book beyond Rosen's digest of it. I myself didn't get around to reading it until after Guston's

death. But once I had read it, Guston's intuitive alignment with allegory as Benjamin set it out made more sense. Over the round wooden kitchen table in Woodstock, where Guston ate and read his mail and his newspapers and sat alone late at night and drank and brooded (he was a lifelong depressive), hung a framed reproduction of that great diagram of perplexity, Dürer's *Melancholia I*. This Dürer, Erwin Panofsky notes, is categorized as a "Melancholia Artificialis," or Artist's Melancholy: a self-portrait of the artist, surrounded by the tools and symbols of creative endeavor—book, inkpot, compass, magic square, hourglass, bell, scales, rhomboid, rainbow.

In the dramas of the Baroque era (including those by Calderón and Shakespeare) Walter Benjamin had isolated melancholy as the allegorists' indispensable tool. Whereas a symbol generally pointed to something else, some kernel that might eventually explode into something limitless (goodness or evil, sublimity or God; something, in any case, transcendentally abstract), melancholy allegory opened nothing. Its vision was trained unsparingly on objects that seemed to have *stunned* reality into a temporary stasis.

This was exactly what Guston wanted from art, too. In a letter to me he once wrote unromantically: "'Art' is not needed; for, like living out our lives—it is putting in some time & activity—staving off the 'other'—the ultimate form. It is nerve-wracking—the need to fix an image forever—like a Pyramid on the desert. It does not move—I am tired of moving—and where is there to move?"

Yet stasis (and its ultimate form, death) only *seems* to be an end-stop. In fact it is merely one of the many guises of ever-renewing

change. While everyone acknowledges that Guston's great reversal of course in the late sixties came by way of his painting non-abstractly again, the more dynamic part of his reversal resulted from the fact that in the last fifteen years of his life he had found a way to paint images of things that almost brimmed with transience and time. Painting after painting offers us plain things with the deadpan capacity to hold history: a hood, an overcoat, a bottle, a shoe, a pyramid, a bug, a wheel, a patched-up sphere, a teapot, a suitcase. Sometimes they're rendered with a stillness that's tragic, other times with an hilarious crudity—but even the most upsetting or disquieting imagery in late Guston has a shaggy, even goofy friendliness, a lack of ostentation and argument. With the exception maybe of Picasso, no other painter of our time so provided a whole, populated-with-surprises world as did Guston in this decade or so of late output—and he did so with a consistent edge of philosophical humor and self-mockery that even Picasso himself did not equal. Details of objects seem to participate in an allegory of the whole. A book that rests open, fat and exhausted, turns into a scroll. Snail-shapes are crawling reflexivities. Two cigarettes held by the same hand speak to a future that obliterates the pleasure of the moment, the now (since one had to be lit before the other, even if by a split second). Be they heads afloat in the sea or a couple in bed or bugs trudging up a ditch, there was a many-ness and interchangeability here that provided what Benjamin calls "a distant light, shining back from the depths of self-absorption."

Paint dries, compositions jell, the eye takes most if not all of an overall finished effect instantaneously—so how is it even possible

to paint time? The self-portrait is one way, faces themselves being composed of time. Rembrandt's self-portraiture is history's most eloquent testimony to this. But in the hands of a melancholy allegorist like Guston, self-portraiture is a stock, too, of particular imagery—and by the end of his life he had managed to make a towering alphabet from this inventory, a signature in which every single letter was a P and a G.

LETTER

T H E *Blanchot piece (translated by R. Howard—not
Ashbery—my mistake) I feel somehow relates to our conversation
the other day. Perhaps you already know it and have it. For me, it
has been a strong MORAL influence ever since it appeared in
'59. I would like to know how you feel about it? To steer one's
life—in art—without being too much of a victim—not to feel too
much ashamed is I think our common, I mean the given—
problem? Who, in his right mind, would not want to give it all up
altogether—but of course we are not in our right minds but
'besides ourselves.' And, above all we truly are not in control. So,
the choices we make in order to put at least a temporary end to
the torture of vacillations that finally can kill. And it does. And so,
there is the treadmill. An exact, noble, yet grinding symbol*

[1977]

2. WEB

Guston's life has been well documented by intelligent and devoted biographers such as Dore Ashton and his own daughter Musa Mayer. But the life itself, its highs and lows, always had a strong tendency to italicize itself. Expecting since his boyhood to be a great artist, Guston acted with the self-assurance of that expectation; when he wrote about himself in letters or essays—or when late in life he pictured himself unsparingly in paint—it was in that trippingly open, nearly guileless way that accompanies the overflow of entitlement.

This kind of presumption doesn't go over well with peers, however, and other artists and critics treated Guston with ambivalence throughout his life. He was much grumbled about: opportunism, fakery, self-promotion, grandiosity. He complained too much, he exulted too much, he slipped in and out of

solidarities. Clement Greenberg, for one, scornfully viewed him as the arch Romantic figure of the New York School, and on those terms dismissed him utterly. And, in truth, always just out of step enough to be relegated to the edges of any particular camp, Guston was easily subject to excommunication. He came relatively late to abstraction, in 1950; and even then, when painting abstractly, he'd write in an essay, "I do not see why a loss of faith in the known image and symbol in our time should be celebrated as a freedom. It is a loss from which we suffer, and this pathos motivates modern painting and poetry at its heart." Or this: "There is something ridiculous and miserly in the myth we inherit from abstract art. That painting is autonomous, pure and for itself, and therefore we habitually define its ingredients and define its limits. But painting is 'impure.' It is the adjustment of 'impurities' which forces painting's continuity. We are image-makers and image-ridden." Then, finally, when he completely removed himself from abstraction's conventions, he was reviled by the downtown faithful and became more than a little problematical to the general art public as well.

He was born in Montreal in 1913. His parents, Leib and Rachel Goldstein, had come to Canada from Odessa around 1905, and Philip would be their seventh and last child. Leib, now called Louis (or, among the family, Wolf), a blacksmith in Russia, labored as a mechanic for the Canadian National Railroad. He did not always work, however, and ultimately the cold and the cramp of Montreal's Jewish quarter seemed too unpromising to the Goldsteins: they decamped for Southern California in 1919. Yet in California Louis's life was not lightened by the sun. He hawked

junk and scrap metal but did not do well, and in a few years' time he killed himself by hanging, with young Philip discovering the body.

The trauma of losing a parent to suicide (to say nothing of witnessing the horror face to face) is something that could easily close up a child's desire for seeing the unexpected ever after. In Guston it seemed to work in reverse, like an immunization: his hunger to see what he wasn't expecting only increased. His canny mother, noting his zeal and facility for drawing, agreed to let him enroll in a correspondence course with the Cleveland School of Cartooning, and he'd then spend the better part of days on the floor of a closet, drawing. Sometimes he'd idly render the light bulb and fixture chain of the closet itself—bulbs and pull-chains becoming particularly recurrent images in Guston's work years later.

Other than attendance at L.A.'s Manual Arts High School (where he'd meet and befriend Paul Jackson Pollock, who later dropped his first name) and taking advantage of a 1930 scholarship to the Otis Art Institute (where he met Musa McKim, whom he'd later marry, but himself lasting there a bare three months), Guston was essentially self-taught. He held odd jobs—driving a truck, being a movie extra—but his passion was to soak in what culture California at the time could provide. He joined an art salon that revolved around the Stanley Rose Bookshop and Gallery in Hollywood, where his work would be part of a group exhibition in 1931. And he had the opportunity to see the work of the modern European masters in the collection of Walter and

Louise Arensberg, his first crucial exposure to de Chirico's work, for instance.

In Los Angeles at the time (as indeed almost everywhere else in urban America) high culture came as something neighborly to leftist politics. And leftist political art at the time lent itself to wall-sized overstatement. In 1932 Guston would go with Pollock to nearby Pomona College in Claremont to see leftist-painter-Stalinist hero José Clemente Orozco at work on a mural. Two years later, with friends Reuben Kadish and Jules Langsner, he actually journeyed to Mexico where, with Kadish, he did a huge mural (still standing) in Maximilian's Summer Palace in Morelia, Mexico, "The Struggle against War and Fascism." Kadish again would collaborate with him on another mural back home, at the City of Hope Tuberculosis Sanitarium of the ILGWU, in Duarte, California (also still standing).

It would be this apprentice mural work that finally allowed Guston to leave Los Angeles for good and move to New York in 1936. He signed on with the Works Progress Administration (WPA) Federal Art Project, where he was surrounded by the most vital American painters of the day, all employed on public art: Burgoyne Diller, Stuart Davis, Arshile Gorky, Willem de Kooning, James Brooks. It's perhaps of note that these painters, each required by the Project to work large, to cover building facades and subway station walls, were exactly those artists who, when the Project finally ended, would bring a significant concentration to their own smaller works: a kind of artistic *tzimtzum*, a Kabbalistic contraction. The clear subject matter of murals was not so easy to

shrink to discrete parts on a single canvas. This prompted the dilemma of showing just this but not that—and in their reluctance to do so, the swerve toward abstraction in all these painters was perhaps subconsciously inevitable.

Of them all, though, Guston seemed to hold back the longest. It seems more than merely coincidental that as soon as a year after Guston saw the groundbreaking Picasso exhibition at the Museum of Modern Art, New York, in 1940, he was willing to leave New York completely, for the first time, taking a job as artist in residence at the University of Iowa in Iowa City. Other than Kandinksy and Malevich and Mondrian, there was little "pure" abstraction extant in European modernism. Picasso and Braque and Léger and Derain (a painter Guston grew more and more impressed with over the span of his life) certainly retained figurative foundations. Almost rhythmically Guston would attach and detach to and from the art center of New York, seismically sensitive to its orthodoxies and to his own ambivalence about abstraction.

The rest of Guston's artistic biography is well charted: Midwestern teaching jobs, the production of dreamily figurative and poignant paintings that won awards, a move back to New York (actually to upstate Woodstock, where he became close to Bradley Walker Tomlin), and then the gradual and painful-seeming move into abstraction. This accompanied a move back to the city, to West 10th Street, and a full immersion in the world of the Eighth Street Club. Close contacts were established with Willem de Kooning, James Brooks, Robert Motherwell, Mark Rothko, and Barnett

Newman. The right galleries of the time followed: Peridot, Egan, Janis. He was included in the 1956 exhibition "12 Americans" at the Museum of Modern Art, then two years later the Modern's survey "The New American Painting," which traveled throughout Europe in 1958–1959. He was one of four artists chosen to represent the United States at the 1960 Venice Biennale. He received a full retrospective exhibition at the new Solomon R. Guggenheim Museum, New York, in 1962, a show that went on from there to Amsterdam, Brussels, London, and Los Angeles. Four years later there was a show of new paintings at the Jewish Museum in New York.

Guston was a difficult man. Omnivorous, narcissistic, brilliant, sometimes verbally fluent to the point of glibness and flattery, horridly lonely, someone for whom nothing was enough and too much at the same swamping moment. A classic manic-depressive, he feared the world's daily demands yet was keen for the homely comic plainness of reality. But despite his demands and his demons, I think we're still obliged to give credit to the unease, even the flooding despair, that by his own testimony Guston felt about these two museum shows of that period. Self-doubting at best, self-disgusted at worse, he felt, viewing his own recent work collected like this, that he had painted himself into a dead end.

Thus, at full tide of reputation as well as self-dissatisfaction, came the startling abdication. After the Jewish Museum show and after packing up in 1967 and relocating permanently to Woodstock, Guston once and for all let abstraction and New York go together. In Woodstock he drew in pen and ink, then slowly began to paint

small panels of everyday objects, as well as hooded figures. Ultimately, as his confidence in these new/old investigations grew, he began to paint large canvases in the new mode. These he finally unveiled in 1970 at the Marlborough Gallery, New York.

Storms raged around him instantly. Old downtown friends felt betrayed. Critics, when not outrightly mocking, were for the most part clueless. Guston took off for Italy for awhile, then returned to all but complete isolation in Woodstock. In the decade to come the momentum of his residual reputation as an abstractionist would carry him into honorary doctorates and membership in the National Institute of Arts and Letters and a professorship at Boston University—but all of these gestures at least half-honored Guston's past, not his present. The present instead was these raw, discomforting, puzzling, and liberated works he was making up in Woodstock.

LETTER

. . . A *painter (now dead) once had a studio in the same loft bldg I was in. He would greet me in the morning with the statement 'Are you not mixing Zinc with your Titanium?' If not, he warned me, it would turn black eventually. Once, at 4 A.M., leaving the Automat nearby, he waved his goodnight finger, saying 'Never use Zinc yellow—it will turn green.' I would hear him always going up to the roof with his samples of color on small squares, exposing his colors to the sun. I once got into his studio and saw nothing but color square samples. Not a painting in sight. Five years later I moved to another loft.*

[1980]

3. SOURCE

Guston's life, it seems to me, cannot be truly sketched without also inking-in his wife Musa's; especially in the seventies, Guston's essential loneliness was the more paradoxical for being such an intensely *shared* one. Like many artists' spouses, Musa Guston all but donated her life to her husband's. Much more unusually, she also seemed to *line* his life with hers—and because of her Guston always was more nearly a promethean artist-and-a-half.

Musa Guston was a small, frail woman. She was preternaturally silent around most people, a whispering commentator whenever she did in fact choose to speak. Philip Roth, using her as partial template for Hope Lonoff, the writer's long-suffering wife in *The Ghost Writer,* termed her a "geisha": the retiring mien, the handmaidenly impression she gave off. She could be eerily

self-effacing. She had been a painter herself, but early on had ceded the art to Philip, instead raising a daughter (also named Musa but called Ingie by her parents), writing poems and plays that were whimsical and delicate and unillusioned.

She watched over Guston like a hawk, but his ambition, depressions, and emotional shuttles made this a thankless, much-stymied job. One afternoon, in their Woodstock living room, when Guston was feeling mellowly expansive, he reached over to grasp Musa's hand, then said to my wife and me:

"Poor Musa. I ask her for her opinion of a picture. She tells me she likes it, but then I think (and maybe I even *say* . . . although I know I should absolutely *not* say . . . but keep *on* saying): *Well, what do you know about anything? You're just trying to make me feel good.*

"The next time I ask her about a picture, she says she *doesn't* like it, I say: *What do you know? You're just trying to make me feel bad."*

Unmistakably a delicate beauty in her youth, Musa was pale and mousy in age, coloring her hair a quiet, dull blonde and pulling it back severely. She was ascetic. I never saw her in a skirt, only buff-colored pants and neutral man-tailored shirts. Her voice was reedy, patchy. Words from it were applied sparingly. She would say "Oh, *yes*"—an absolute recommendation, a life's hard-won discrimination inside the simple two words. And when she took a more acidic view of the many people who passed through Guston's life, she'd often say, "Oh, he was a *terrible* person." You realized when you heard both these expressions, these almost childlike *Ohs* that were at the same time the highest temperatures of conviction, that they came from someone not spiritually of the

modern world at all but perhaps instead of the nineteenth century. Strained through Musa's reluctant voice (and her silence) came the sound of moral perfect-pitch and utter focus.

For she was a good deal more than just self-effacing and economical—she was an ellipsis unto herself. The more she camouflaged and edited herself, the larger she grew. Guston's late paintings sought not only to give shape to Musa-the-enigma as a sphinx or icon but also maybe as those late pictures of bugs climbing over rocks—the dot-dot-dot of complete determination. Determination and utter concentration was the mutual engine of the Gustons' union. Both their powers of renewal were astounding. Whenever Guston painted Musa—and he did so over and over—her image would be graced by a dab of green, that color in a middle or late period Guston almost always a marital gesture. He would title his most famous painting of her *Source,* a neo-Egypytian emblem fleshed-out from the stenography of a fifties abstraction, the circumflex of *For M.*

In 1977 Musa suffered a stroke.

> *. . . This is to be a doleful letter—a dirge. —Since your visit I've seen no one save check-out girls at the A&P. Musa, it seems to me is progressing slowly but it will be a long pull—memory and the naming of things lags. Doing household chores made me lazy—I ate— slept. Laziness turned into lassitude and melancholy,*

finally solid despair. Old friends, of course, but I never seem to learn. I console myself—notions about the ancient angel of forgetfulness. Preparing for the new, and as I've just barely started making images again—thinking I had so much capital to draw on, but no—now comes the dismantling—the desert again—my appetite for what I haven't yet seen. . . .

Even before this calamity, in paintings referring to himself and Musa, there were chilling touches of paralysis and premonition—never more so than in *Web* (1975), a painting about death's terrible net. It is as if Guston has taken the picture plane and rested his deflated world upon it. The painter has somehow been toppled, dropped like a statue of a dictator overthrown, dusky with grief. Beneath him, from his big painter's eye, leaks a bloody wound of impotence and preoccupation.

The other head—Musa's—is purposely eyeless and frontal, leaking a puddle not of remorseful red but of the freshest, shyest green, her color. As in many of Guston's works, Musa's head is so close and annealed to his, that he has only to make a self-reflection—and she is right there, too. One toppled, one upright, the two heads are the heel and sole of a single shoe.

The plane above them both is given over to fate itself. The bugs up there have a closeness that speaks to a unitary power that Philip and Musa seem to have lost. The bugs' silk webbing, red and white, covers Musa completely (her fidelity to Guston never was breached) but merely a bit of Guston (who too often was faithful

only to himself). Under the web there is a disquieting pollution of black, pink, and red. The damage being done seems to have left only blasted heath.

Although it is thoroughly a picture about grief, no sentimental aspect is permitted at all. The spiders seem to see to that as well. They pile-drive Philip back into Musa. He may not be able to see her straight-on anymore, yet his base is tapered and reduced down to her specific proportions. He is awash with guilt. The train-track eye, elaborate enough to look almost armored, has never before in Guston looked so inutile, so pointlessly open. It is fixed and may in fact never close again, like some curse or the ever open eyes of death. Below Musa a bit of pink smoke leans out. She cannot rise, but before descending unreachably, she first sends out ahead of her some of her essence.

In the same way that certain Van Goghs seem less made with paint than with distilled emotion; or as Eugenio Montale's great sequence of poems about his dead wife, *Xenia,* seems barely to be made out of (or for the sake of) art, not a single one of *Web*'s inches congratulates itself. The awful bugs, the matte finish, the reduced pale colors all prevent it. Instead it exists in a suspended state of incipient erasure.

———————

In dozens of paintings done in and around this fragile season, Guston found himself fused to Musa in his art as well as his life as never before. *Wharf* (1976) is but one of the more remarkable evidences of that fusion.

Appropriately enough, it's a kind of ruin. A glass contains ice. Guston's own head, in profile, is innerly supported by the outline of the glass. His fingers grip a brush that is in eastward sweep upon a stretched, easeled canvas. Facing us is Musa's head, her martyred eyes upturned. And finally, neighboring her, is a farrago of dismembered joints and extremities topped or bottomed by the soles of shoes. The entire pierlike mass—glass, painter, canvas, woman, limbs—juts into a sea hard and slatelike enough to throw back glimmers of its reflected light to Musa's forehead. A gray and red sfumato of weather hangs around the wharf greasily, ominously, but farther up this is pardoned by a sky of gentle blue.

It is a proscenium-arch painting, a congregational painting, a *we're-all-in-this-together* comic painting. Yoked all together in it are the three modes—theatrical, asymmetrically plural, and philosophical—that late Guston wrapped almost all his greatest works within. In a descending scale of guilt (the painter's addiction to vision and to booze, the mediation of a woman's sorrow, the dumb architecture of the legs) Guston makes his own head and his own glass and his own easel be the sharpest things here, with everything else softening as it goes west. As elements interrupt other elements, incongruously getting in each other's way, we're allowed to see that in the last ten years of his life Guston, Musa, *and* these mysterious "whatzit" images *were* the family unit.

————

Maybe the happiest picture Guston ever painted appeared around then as well. The joyful *Cherries* (1976), a large canvas about

multiplicity (and its darker corollary, gluttony) is maybe the most sterling example of what I see as Guston's style of congregational composition. This is a satisfiedly "dumb" picture. Guston had nothing but scorn for Greenbergian color-field painting—"'Over-the-couch' things," he liked to call it, "a decorator's dream" (which was a doubt he ultimately entertained, less happily, about the work of his old friend Rothko as well)—but *Cherries* would be a picture that Guston would hang near his own sofa in his small living room, where it dwarfed everything else with its cheer. The domestic comedy of the largest cherry squashing the smallest one, which has gone a little pale under the pressure, is a revival of Guston the cartoonist but also is a self-mocking comment on Guston's domestic life.

It is also the work of an extremely sophisticated artist going a very contrary way. After Cézanne and Morandi the decorum of painting simple objects usually has been to invest them with so much indwellingness and immanence that they approach transcendence; to coax out the apple-ness or bottle-ness of each object and set it free into space to reverberate past the simple forms of the objects themselves. But this painting, *Cherries*, one of the rare Guston still lifes of this size, is full of tricky *anti*-transcendental grace-notes. The picture's circles originally were meant to be ashcan-cover shields—the martial memory that was showing up so strongly in a picture such as *The Street* (1977) — but with a sense of summertime clemency the subject turned effortlessly into a Guston enthusiasm: early summer cherries.

The cherries are situated on black water, the melancholy essence that Guston always paddles in, with lengthening hatch

marks given off by the middle cherry as reflection. But each one is painted exuberantly, with glints of shine. The black cherry at the rear is an outcast (it certainly looks like a bomb) but it too still adheres good-naturedly to the society. For with one exception the cherries touch each other and are communal, with the proximity as well as the isolation of neighbors. The same one mouth, after all, will devour them all.

Abundance isn't at all the point of this spill of fruit. Unbalanced asymmetry is. *Cherries* can be seen as simply one of Guston's cherished ball-chains laid out on the horizontal and relaxed into disarray. Like so many plural objects in late Guston—legs, bugs, shoes—the cherries here are a delirious congregation of imperfections.

LETTER

I T H I N K *you are writing about the <u>generous law</u>*
that exists in art. A law which can never be given but only found
anew each time in the making of the work. It is a law, too, which
allows your forms (characters) to spin away, take off, as if they
have their own lives to lead—unexpected, too—as if you cannot
completely control it all. I wonder why we seek this generous law,
as I call it. For we do not know how it governs—and under
what special conditions it comes into being. I don't think we are
permitted to know, other than temporarily. A disappearance act.
The only problem is how to keep away from the minds that close
in and itch (God knows why) to define it.

When are you coming up? Do you wish to? Would you rather
I came in? I'd hate to have you feel that you should come up—I
mean, no need to fulfill a promise naturally. But if you'd like
to—me—Musa—the work—all here—yours.

[1978]

4. BLUE LIGHT

Like most everyone else I knew Guston first only through his paintings. Growing up in New York in the late fifties and early sixties, I wandered through the two great adjoining museums of Fifty-third Street, the Museum of Modern Art and the Whitney, precisely during the years when the sovereign, gorgeous Abstract Expressionist paintings were pushing their way into those collections. Guston's abstract work—the halftone refinements, the ragged centralities in a modulated palette, a style so classically discreet that he was able to be dubbed by some as an "abstract impressionist"—particularly appealed to me, a teenager with a taste for subtlety.

By the mid-sixties a more personal connection to these paintings happened to be forged for me. Riding the last wave of twenties-through-sixties Village bohemianism, the pedigree that

runs from Edmund Wilson through Dawn Powell to Franz Kline, I took a literary apprenticeship that located itself not in college writing-programs but in downtown bars like Max's Kansas City and the Cedar Tavern, the Metro, the Lion's Head, the Ninth Circle, the St. Adrian's Company; or at jazz clubs: the Five-Spot, the Half-Note, Slugs, the Dom; or at uptown art galleries, or at the Poet's Theatre on Fourth Street, or in slum apartments. The older writers who befriended me (and my peers such as Michael Stephens, Andrei Codrescu, Tom Weatherly, Paul Auster) were poets, prose writers, and quite frequently both: Gilbert Sorrentino, Fielding Dawson, Joel Oppenheimer, Paul Blackburn. All these writers were fierce downtowners. Each, at least outwardly, seemed to regard their neglect by the greater literary world as a kind of inverse prestige, a bohemian *superbia*. William Carlos Williams had entertained excellent relations with painters of his day such as Sheeler, Demuth, and Hartley; these heavily Williams-imbued and Black Mountain College–oriented mentors of mine highly valued the virtues of cross-pollination, too. By locale and through personal contact, their titans were the first-generation New York Abstract Expressionist painters: Pollock, Kline, de Kooning, Guston.

It was filtered down to me, therefore, that a writer found himself at least partly underequipped for the creative life if he didn't acquire at least one visual-artist friend to share it with. Here I happened to get quickly lucky. One afternoon, in a literature class at City College my first year there, I accidentally found myself sitting next to one. Archie Rand was a little younger than I was. Both of us originally were from Brooklyn, as well as from that

lower-middle-class Jewish post-war urban cohort that instinctively looked upon intelligence as a competitive event. If anything Archie was more precocious than I was (he'd had his first gallery show when he was seventeen) and more artistically omnivorous (he knew as much about Cecil Taylor as he did about Delacroix). And both of us, through inclination, had absorbed what now seems to me, looking back, to be almost quaint downtown aesthetic principles: experimentation, self-knowledge, intensity, a heroic love of the past.

We went together to see Guston's controversial Marlborough show in 1970. Guston's hulking beautiful/miserable abstractions of the early sixties had made way for a threatening carnival: thugs in hoods smoking cigars and holding nailed clubs. They were surprising, exhilarating, fearless, chopped-open pictures that went by us like wind against our lips. When five years later, in 1975, Archie's brother, Harry Rand, a contributing editor at *Arts* magazine, asked me whether I'd be interested in writing about a gallery show of Guston's newest paintings, I was more than ready to give it a try.

Half a decade after Guston's scandalous show at Marlborough, his "re-debut," so to speak, it had been interesting to watch the shape his heresies took as they cooled. The hoods slowly had disappeared. The Keystone Kops raucousness was modulating. A certain spacious discretion, resulting in such landscape-like works as *Ominous Land* and *Painter's Forms*, both 1972, now was in evidence. Guston, it seemed, was not quite sure where to go next with his freedom in the paintings of the early seventies.

For its part, the art press of 1975 seemed to have more or less put Guston aside as yesterday's scandal—his novelty had been good for only a short time. Hardly anyone actually ever bought a post-1969 Guston, and all his shows seemed to be reviewed as a continuation of what he'd done once in 1970, perhaps sufficiently. This may have had to do with Guston's age at the time, fifty-eight, as well as with his relegation, by a few doctrinaire critics, to second-rank status on the Abstract Expressionist podium.

Some of the lack of attention may even have had something to do with his choice of a gallery. Guston had decamped from Marlborough after 1970 and gone over to a new gallery opened in 1974 by David McKee. Young, thoughtful, and British, McKee was a former Marlborough associate who, with his future wife, Renee Conforte, had gone ahead to lease what perhaps was the most unlikely exhibition space in New York at the time: the mezzanine floor of the Barbizon Hotel for Women on Lexington Avenue and Sixty-second Street. Taking the staircase from the lobby, you either were headed down to the hotel's swimming pool or up to the McKee Gallery. (Women clutching towels and workout bags far exceeded gallery goers.) About this fledgling gallery there was a nearly comic out-of-the-wayness, and the lack of art-world gloss to Guston at the time (something he'd deliberately stripped away himself) only accentuated the far-flung-outpost-feeling of McKee.

In the 1975 McKee show I reviewed for *Arts* there was a triptych of large flood paintings that clearly, even in a re-invented Guston, was something remarkable and renewed. For the War

Department, in 1943, Guston had produced a series of drawings and gouaches of sailors shown training for emergencies in the water; and the compositional setup of this floating imagery had stayed with him as something essential to his vision. Just as Kafka recognized early on that his own unconscious tended to schematize existence into the awareness that Little has of Big, so Guston, too, had his own psychic world stripped down to the complements of dry and wet, sand and sea.

In these three large 1975 canvases, the depth of the seas (an ocean of cadmium red medium, unoxygenated blood) gave the odd impression of coursing *upward*, a diagonalism that would be refined in many pictures after these. The darkest of the three, *The Swell,* featured a lolling head that was Guston's own, six or seven distinct strokes of the brush done with eagerness and ease. In *Blue Light,* a *Commendatore* figure was stared-down by a larger, Olmec-like head, the cranium of which looked like one of the shipwrecked shoes sticking up here and there. Down in the lower right corner of the same picture were planted sections of canvas-stretcher resembling a pier with a ladder, should any of the awash figures be ready to try to climb out onto dry land.

So these were works not only about submersion but also about dogged *re-appearance,* a swirling down but also a bobbing up. The wharf becomes a recurring image in late Guston, one of a repertoire of anchoring landmarks set down in an ocean or desert: floorboards, ladders, monuments, pyramids, even shoes. These hulks suggest a supervening level to Guston's comic pessimism: that in fact all may *not* be quite lost. They make an un-despairing

bet that things, rude stuff, actually do exist independent of our belief in or intellectual rationale for them; that they are there to be happened upon. "He who seeks to find himself is lost," Jean Starobinski writes, "he who consents to be lost finds himself"—a cognate truth to Picasso's often heralded statement: "I do not seek; I find."

———

The short page-long essay I wrote about that McKee show of 1975 spoke only a little and in conclusion of that amazing triptych, occupying itself more with an overview of what Guston had done in 1970, about why perhaps it had been so alienating and where it might be going next. Half a year after the article appeared in print, I received a surprising note in the mail:

Oct 26, 1976

Dear Ross Feld

Only my lassitude has kept me from writing you—I've been wanting, for months now, to tell you how much I liked the piece you wrote on my work in The Arts, last April or so. I don't remember writing a note such as this, but I wanted you to know how I felt when, to my great astonishment, (and pleasure) I read your singular article. Everything you wrote in it was so personally felt by you and expressed in such a close and fascinating way, rarely if ever found in the art magazines. I felt as if I were reading

thoughts about my work with great excitement—and more—as if we knew each other and had had many discussions about painting and literature. In a word—I felt great recognition. Please accept my deepest appreciation and thanks.

Most sincerely

Philip Guston

I answered the note. A few days later, Guston phoned me at home and we arranged to meet at the McKee Gallery the following week. David McKee accompanied us downstairs to a luncheonette on Lexington Avenue. We ordered coffee and buttered rolls, but before any real settling-in could be done, first impressions and first measures taken, Guston immediately, and without any preface, launched into the following story:

Back in the thirties, he said, while he was working for the WPA, he'd gone one evening to hear a fiercely serious German scholar give a lecture on Cézanne. Guston, after the lecture, waited for a downtown train on the platform of the nearest subway station, and while standing there spied the Cézanne lecturer on the same platform, also waiting for the train. The lecturer had in addition just treated himself to a candy bar from one of the vending machines on the platform.

Guston said that he could see the candy bar's wrapper: the scholar had bought himself something called a Love Nest. Guston began walking toward the man to pay his respects and thank him

for the talk, but when the august German realized he was being approached, he quickly began stuffing what was left of the Love Nest into his mouth.

Guston explained to McKee and myself:

"Now Love Nests were very gooey. A little, *little* piece stayed on the guy's mustache the whole time he was talking to me, making the points of his lecture all over again, marveling over Cézanne's genius. All that time, with every word he spoke, the little piece of Love Nest above his mouth danced up and down, up and down."

Guston could have told me any story out of his repertoire of hundreds, especially funny ones. Yet on the day of our initial face-to-face getting-together he recounted this one. Sly warning had been given, I realized. Guston was introducing me to his own Love Nest, the one he lived in and painted with—where impiety, impurity, and the plainly embarrassing were raised up high and celebrated, not swept away or covered up.

———

Guston always had been particularly close to writers—William Inge, Frank O'Hara, Stanley Kunitz, Robert Phelps, Bill Berkson, Philip Roth, Clark Coolidge, myself—some of whom had written about his work, some not. The need painters have for writers, from the time of Vasari onward, seems ultimately to have less to do with ego-gratification than with a simple change of lighting by which the artist's works can be known. By words visual imagery is given a second vividness. And writers recast it into a descriptiveness that's infinitely portable.

I was twenty-nine in 1975. But recovering from Hodgkin's disease, fatalistic beyond my years, I also lived lightly and more than a little warily on the surface of the world, carrying that double passport the ill bear in the world of the well. Guston, nearly thirty years older, had been rejuvenated, but also marginalized by his new freedom. What formed between us was, in a certain light, the least likely comradeship. My wariness and vague standoffishness, his liberation but also near-crushing isolation. In my careful-stepping, self-protective state of being during those years, Guston's personal heedlessness and excesses—he was like a large, whirling Zero Mostel, a supernova of personality—easily swamped me.

Somehow, though, at the same time, this also seemed to hold us fast, like a Chinese finger-cylinder that tightened as we instinctively pulled in opposite directions. Now I know that we made a not-so-odd-couple after all. Guston's startling late freedom had been a rebirth—one of which I'd experienced, if more passively, with cancer myself. There's a Biblical midrash that ascribes Isaac's growing blindness as an old man to that earlier moment when he'd almost become a boy-sacrifice: "When our father Abraham bound his son upon the altar, the ministering angels wept and tears dropped from their eyes, leaving their mark upon them. And when he grew old, his eyes grew dim."

A price is paid for knowing about death too well too young. In my own case, narrowed of vision, psychologically cataracted, one of the things I got to see most clearly in those post-illness years just happened to be Guston's extraordinary pictures. I'd never seen anyone else's pictures quite this intensely before; I have never since.

LETTER

Sunday—Sept. '78

Thoughts (or Advice to myself)

Ross,—So it is truly a bitter comedy that is being played out now—A 'Painting" which is like "real" life—as it is lived from hour to hour, day to day, <u>cannot</u> be a picture! It is an impossibility! Feelings change—keep shifting—it is a fantasy the mind makes, the attempt to <u>fix</u>—it could be like accepting a dogma of some kind—of belief. But it won't stay still—remains docile—. One cannot tame anything into docility with oneself as the master—be a lion tamer?—that is razzle-dazzle, that's circus. Fool the eye.

Sometimes I spread out all over the canvas, the rectangle of action, and try to fix—make the momentary "balance &

unbalance" into a form that I can look at—"live with"—and because of its very instability and precarious condition I can. I did this last week. Now, this week, *in reverse*, I made a huge & TOWERING vast rock—with platforms—ledges, for my forms to *be on*—and to play out their private drama. A Theater— maybe? A STAGE?

This will remain for a while—this series.—Of *course* they needed platforms—steps—to act it out. But then the *rock itself* became precarious, shaky and wouldn't stay still—it, too, participates in the changing instability of everything. So even when I want & need to make something solid—just *there*—like a Pyramid—it starts shaking and the whole thing—the rock as well as the forms are swarming—moving in all directions at once—As if there were *no* possibility of *any* kind of order—that we know of, or have seen before. If we are weak, we distrust it?

So, if things are moving, changing so rapidly, it is folly to hold—to fix—Yet the attempt *must* exist—& be made. Why?

If I think of the forms *as on* a surface, on a flat plane—if I give in to the *limitations* of the plane, its restrictions, and accept its orders, OBEY, and follow through to a fixation, one inevitably ends with a "nothing"—an emptiness, which is similar, I think, to the flatness of a belief. A PURITY. This is a fantasy I cannot believe in, for I then become tedious and boring to myself—*reminding* myself, *remembering* what I thought or felt yesterday—what the rules are, or were—*Here* is where it *all* tumbles and collapses! The image then becomes "a picture"—a sign—an icon—and even though it can be a "significant" and deeply felt "nothing" (OR A THOUGHT) it does soon pall.

*And when I go to the other extreme and <u>resist</u> the acceptance of
the flat plane of painting—and be perverse and go against the
rules, so to say, my image is like a hunk of sculpture—solid—a
"thing" in space—When I am <u>too</u> resolute—firm—in this
resistance to the flat—the image soon palls, too, and becomes also
fantasy, depending too much on illusions. And this chunk of a
"thing" is painful—stays in the gut. Either way, we are still in
the old & familiar wax-works museum.*

*What, then, is there to do—where, then, is there to move?
Only the most feared is left. To create a living thing—<u>as it</u>
lives—<u>and to see</u> it! <u>Impossible!</u> (It is somehow evil to make a
Golem, but to make a living "thing?") That is a far greater
evil—(also "unnecessary").*

*So, to abandon yourself to the unknown of the doing—is all
that's left, only the reflection of the passing of time—but sharply
visible—made so—as this act of making is lived out.— And—
then you move into the next, like a strange and new clock,
warping Time into becoming a frightening new other place, a
land in which there is no rock and no "nothing." What is
<u>there</u>—then? There is only the next doing which leads only to
the next doing. A lifetime of doing?*

*Nerves. The nervousness of the maker is what one has—very
little else—and even the "else" is rancid,—like old & dried sea-
weed clinging on.*

*Advice to myself—
Do not make laws.
Do not form habits.*

You do not possess a way—
You do not possess a style—
You have nothing finally but some "mysterious" urge—to use
the stuff—the <u>matter</u>.

The Buddhists write—
"When you walk, walk—When you sit, sit—but know that
you are walking—know that you are sitting."
But I am not a Buddhist—even that is denied me. My spirit
needs <u>matter</u>—a <u>medium</u>—which resists the peaceful—balanced
resolution of forms and spaces. I need a medium through which I
can show myself—to myself—concretely—tangibly—what
I am—what my condition is. Unlike a monk, my self or mind-
self is <u>not</u> my medium—I cannot contemplate myself <u>into</u>
myself. I don't know. It could be that the Buddhist's way is an
ultimate state which I have not reached. I am not certain if this
is true. I doubt it. Yet could it be that it <u>is</u> vain—for the self to
show itself to the self, and also know that this is what is being
done, as it is being done, & in such a way that it cannot stop this
being done? Corporeal. Fleshly. Is this what it is then, to be an
artist? It is a question of some magnitude.

P. G.

5. TALKING

He dressed pretty much according to Brooks Brothers: oxford shirts, khaki pants, brown Weejuns, a roll-collared over-sweater. But the shirts were at war with his neck and belly, and he frequently looked faintly tipsy or rumbustious in them, the sleeves carefully folded up two turns, his cigarettes—Camels—crushed down into the breast pocket.

His face, head, and torso were thick, projecting great mass. Slightly bowlegged, he walked with a rocking side-to-side motion. But his fingers were delicate. He used the index and middle ones together like a snake, a baton, a staff, a smoker's apparatus, a *This-Way-Out* sign; and had a way of laying them across his cheek like a resting, watchful animal. When these two fingers appear in his paintings, however exaggeratedly, they have something of the still and commanding authority of Dürer's two

straight digits laid upon his sable collar in the epochal 1500 Pinakothek self-portrait.

Guston had an uneasy relationship with his body at best, at worst a punishing one. Other than his arm, he seemed not to have any great trust in its parts, and perversely he'd enjoy coaxing it to the edge of disaster. A diet of rich foods, of too much vodka, of pack upon pack of Camels ran roughshod over his health. He had numerous what he called "breakdowns." During the time I knew him he checked himself once into Johns Hopkins, another time Massachusetts General, looking for and finding ulcers and fatigue (masking alcoholism and manic-depression) and being duly warned not to smoke cigarettes, to moderate his habits. He'd then tell the doctors, I am not a man of the middle, and retell the story later to anyone who would listen. To his friends it was a ritualized, disheartening melodrama.

Especially when he was in Manhattan, Guston could operate as one large oral appetite. He was not indiscriminate, yet it pleased him to elevate small ethnic restaurants—a Yorkville Hungarian place, Chinatown storefronts, unpretentious southern Italian joints he'd discovered—into private shrines. After he'd been awarded an honor by Brandeis University at a public ceremony at the Guggenheim Museum Auditorium, a group of us ended up in an Italian place that was a good deal fancier than what Guston normally approved of, not peasant-y enough but the only place nearby that could seat a party of eight. Immediately Guston set to charming the waiters (in Italian) into a conspiracy of excellence. They were to steadily convey to the kitchen that it should turn

out the real thing, outdoing itself by cooking as though it was a night in Umbria.

In the city he seemed always to be at his most manic and talky. Making the rounds of gallery shows of old students, shopping for supplies, eating in restaurants, drinking in bars, visiting old friends—a New York day spent boulevardiering with Guston was essentially an exercise in raconteurship. Old set-piece stories about the thirties and the fifties tumbled out of him as he passed this place or that. But ultimately Guston's New York was like an old comfortable raincoat he could take or leave home. It was only when I first went to visit him in Woodstock that I found myself provided with Guston whole.

Afternoons in Woodstock were largely spent in running errands involving the next upcoming meal. Guston drove around in a small Toyota Corolla, a no-frills car that delighted him inordinately. (He'd earlier owned a rare Rover sedan, and the challenge to maintain it in a small upstate town had completely defeated him. "I'd drive down the street of the garage. Just the *street*. The mechanic would spot me. With a look of panic in his eyes he'd run out and wave me off: *No! No!*") Together we once drove over to a butcher shop in Saugerties. One of the many emptied-out Hudson River towns that resembled the stunned arcades of de Chirico, downtown Saugerties seemed barely alive. Guston was greeted effusively by the butcher, who knew him so well that at one point he seemed to be on the verge of inviting him over to the other side of the counter in order to grab a knife and help cut the roast. You saw this kind of thing with Guston not

infrequently. He was at home in the world, which in turn tended to welcome him. He had unusually democratic, uncondescending social skills, tending to most people as though they too were artists or at the very least holders of individualized knowledge it was a waste not to try to elicit from them.

Back in Woodstock, in the kitchen, Musa would have made a salad and the vegetables she anxiously tried to get into Guston— to counteract the cholesterol-sodden main dishes: the spaghetti carbonaras, the pork loins, the sauerbratens and schnitzels that were Philip's domain to prepare on one of his vanities, his restaurant-quality Viking stove. With these meals the identical Sicilian wine was served always, Corvo, either red or white; then, after the dishes were cleared and washed and maybe a ripe pear was eaten with pearl-handled Italian dessert knives and forks, the real visit would begin.

In Woodstock the Gustons lived in a small cedar-shake cottage, a summer cottage fashioned into a year-round home. There was just barely enough room inside to contain them both. Yet across a gravel drive, ten or so yards to the west of the house, was Guston's long low cinder-block studio. Its gigantism and additionalness clearly stated where the largest and most unbuttoned part of Guston resided. Warehouse-sized by the time I knew it, it had begun as a smaller structure. Two-thirds of it, separated by heavy walls and a fireproof, heavily-alarmed door, served as storage space. The other third had been broken in half as a spare, pleasant guest room and as Guston's work space.

This work space lent credence to Guston's often repeated belief in Leonardo's maxim, *La pittura es una cosa mentale*: painting is a

thing of the mind. There was a painting-wall that canvases-in-progress were tacked to, as well as a long table to draw at, plus a rolltop desk for writing, and several worktables filled with paints and brushes. But you came away with the overwhelming sense that Guston worked in a physically modest, almost restricted amount of space, no grandly gestural openness required.

What *was* unrestricted was the storage room. Temperature-controlled, high-windowed, bathed by fluorescent tubes, it was raw, soulless warehouse-y square-footage. But it was also where Guston's imagination literally had collected—and at this stage in his life quantity of work had drawn even with quality in significance, a majesty to both. For from 1975 onward Guston was unstoppable. The storeroom held the residue of frenzy.

Musa would go off to bed while Guston and I would walk across the gravel and go through the store-like glass front doors of the studio building. Not even for a minute did Guston ever want to talk in the comfortable guest room or in the painting area. He didn't want to talk about himself or about me or about art, philosophy, poetry, or politics. Those all could wait. He as much wanted me to see his new work as to see it again himself.

A guest could have a canvas director's-chair placed near a support post midway in the storage room. Next to it was one Guston himself sat in, and beside it was always one of a number of floor-standing ashtrays the studio contained. The room was cavernous and invariably chilly, its fluorescent fixtures humming and ticking. Guston would sit for a perfunctory moment, then be up to show what he'd been up to: knees and legs, piled-up heads, autobiographical pictures of himself and Musa, bugs, pyramids,

overcoats. Sometimes we brought the chairs nearer to a particular painting, and he might loosen his belt around his paunch while he sat. A minute later, rising excitedly to point out a detail, he'd come to his feet and find his pants around his ankles. Retrieving them with one hand, he'd nonetheless be pointing with his cigarette in the other and just go on talking.

A painting of 1979, *Talking*, is to me almost an emblem of those nights. In the picture Guston's sleeves are rolled up to the length he habitually rolled them, as in the dark he is going to put on a light. Of course he cannot possibly pull the light on with so much in his hand. The thumb seems to reach back for the chain impossibly, giving it a doomed shot while at the same time a sense of strain is expressed by the bluish tint to the clenched bottom fingers.

It's also a now-and-later diagram, this painting. The watch's single hand says that the time is resoundingly, unambiguously *now*. Guston was a great reader of Henry Green and a profound appreciator of Green's gerundive titles: *Loving, Living, Concluding, Party-Going*, etc. He'd say that to him the titles and the novels themselves were embodiments of fluidity, of states of being experienced in time and therefore subject to no easy capture. In this painting, talking also means always being in some state of relative darkness or ignorance or half-knowledge: Guston would wake in the night to go back and look at his work of that day, and here the thrust of the hand, so burdened, fumbles and misses the chain completely. And as a modern poet of the cigarette equal to Svevo in *The Confessions of Zeno*, the cigarette for Guston was the

most homely, appealing clock of them all: burning down, fitfully drawn at, used, disposable yet addicting—a kind of little life held between the knuckles.

———

Toward the night of a visit he'd already have had Musa or his handyman Ed Blatter help him turn out the larger canvases to be viewed. These showings had none of that highly doubt-wracked, worried weather his friends had reported from the earlier decades. If even a seminal picture such as *Monument* (1976) (now in the Tate) or *Tomb* (1978) (now in the Museum of Modern Art) struck him as significant it wasn't as a catch basin for any aesthetic dilemmas or victories. He'd largely gone past those. "Cross-grain" was how Guston described his basic artistic temperament—"You want to fight against what you do well"—but back when he was a modernist-impossibilist this meant swatting at ghosts and shadows, resulting in existential dramas. Now he was hungriest for *seeing* something new in a regular way.

This was maybe why to see the pictures for the first time while standing beside Guston wasn't nearly as unnerving an experience as it could have been. Having the door to that big chilled room opened for you was instead a sumptuary experience, and I often found myself at ease in an almost lulled way. Though the paintings were rife with "subject-matter," their profound, even crude unmannerliness and obverse beauty did not require any kind of formal or solemn notarization. Guston was so available to his own scarifications that a visitor like me was more or less let off the

hook, not even really expected to take it all in, since the images of those years had come out of Guston almost clatteringly. If he'd been bespelled enough to write to me in a letter about a particular picture, by the time I got there, there would be three more just like it, and two more that extended these into a new area altogether. Guston once said to me about *Head and Bottle* (1975): "I'm just seeing how much I can stand." On those nights of my visits I sensed he must have also marveled at just how much in fact it was that he could stand.

Usually I'd have something to say to Guston about the canvases either by way of lifting out a detail that spoke of the whole ("Anna May Wong," I noted to him once about one of the first-rank heads in *Group in Sea* (1979), to which Guston coughed his way through a small laugh, liking that one of his cheesier obviousnesses had been smoked out)—or by a kind of reading back to him of what he'd turned toward my eyes. On my part there was less inspiration to this than an odd and recent kind of personal routine. Around the time I first met Guston I had begun to write a half-dozen book reviews a week for the prepublication review service, *Kirkus Reviews*. My wife was in medical school during those years; I was trying to do as much freelance work as possible. The partial clue to writing for *Kirkus* was being able to reconstitute the situation and plot of the book being reviewed by brief summary, by a kind of re-narration. You were free to lard-in whatever critical, qualitative judgments you wished, but the basic craft was of retelling stories not your own. And Guston's pictures certainly *were* stories, or parables, or jokes—mysterious narratives in any case.

I didn't like every picture I was shown. The most allegorical ones (no surprise) usually defeated me, or else the more overtly literary ones. Guston paid homage to some of his literary heroes—Kierkegaard, Eliot, Jules Supervielle—with canvases that would always be titled with initials. One of these was a picture that I remember leaving me especially cold: "For I. B."—I. B. being Isaac Babel.

"Too much your territory?" Guston asked me mischievously.

The word "Odessa" had been painted in, and the planetary rump and waxy tail of a Cossack's horse taking up most of the canvas's center. It wasn't literariness or illustrationism that I objected to but instead obviousness. Yet obviousness by that point not only was not taboo for Guston but occasionally strictly necessary, even crucial. To make obvious was sometimes the by-product of making *see-able*.

LETTER

Dear Ross, Just completed a picture (Picture?)—the last stages
of doing it was a 24 hour bout—so many images and structures
painted out—They do not satisfy now. Something is happening
to me and I do not know what it is.—As I look at it now, after
some sleep, it feels so compressed—ordained and remote. Yet it is
so simple to look at. No—it is not simple to look at all. It is as
if it is now all for the mind—whose thoughts are pinned—
riveted down—but it moves in the mind—IN A NARROW
RANGE—moves, not roams. The least—almost nothing for the
eye—just enough—one even doesn't need to "look"—too
unnerving. When I am away from it, my thoughts revolve around
this image. Where has it been before, masked & hidden. I think I

have known this image all my life but did not make it visible before. And it is not possible to retrace all the steps that led towards this finality—like running a movie backwards. It would be delicious to remember all those pretend "finished" images that were painted out—but I cannot remember—bits, pieces, maybe—as if my mind does an erasing job on memory, since <u>here</u> concretely is the doomed outcome. I began shaking— trembling, when it was done. As if an heretofore unfaced truth (a verdict?) was at last faced. Everything else feels frivolous to me. Now where do I go—move.

"Art" is not needed; for, like living out our lives—it is putting in some time & activity—staving off the "other"—the ultimate form. It is nerve-wracking—the need to fix an image forever— like a Pyramid on the desert. It does not move—I am tired of moving—and where is there to move? Who hasn't heard that "art" is "life-enhancing"—the "élan vital," and etc, etc. As if art was an exerciser, a bicycle, in the living room.

I have known, but did not permit myself heretofore to recognize that art is death—<u>a</u> death. That the purpose of creating is to kill it or at least get rid of it—once and for all. Now, I truly am fearful of creating—such a dread of it.

Our processes are <u>so</u> mysterious—I know I'll begin again—to relive the same experience.

I felt like talking to you.

[1978]

6. FRIEND

In 1979 Guston suffered a catastrophic first heart attack. His immediate recovery was stormy and unsure. While in the Kingston, N.Y., hospital he suffered *delirium tremens* from alcohol withdrawal, and when finally allowed visitors he looked beached in the bed, a gasping whale. He seemed only partly pleased and half convinced he had in fact survived, and anxiously he pressed on me a yellow legal pad on which he'd written certain last requests should this in fact turn out to be his deathbed he lay on.

Attended by a confused and nearly mute Musa, by Musa's sister Jo (who also lived in Woodstock), by Jo's daughter Kim, and finally by Musa Mayer—Gustons' daughter, Ingie, who'd come east from Ohio—Guston had a quartet of women to help and worry over him. And it was clear to everyone that if Guston was

to have any hopes of recovery they would have to all but sit on him to make him take it easy.

That never would have been a great bet, and it turned out not to be. Guston was an impossibilist in every way. After the heart attack he blithely ignored every stricture; he never stopped smoking or drinking or eating the way he liked to. Once he was back on his feet and we were together one day in the city, he and I went downstairs to a dismal McAnn's Bar near Grand Central Station to get some lunch. It was Guston's cherished theory that the more unpretentious the restaurant the better—but in this case, no. Standing in front of the steam table, he promptly ordered a sandwich cut from what plainly was the deadliest slab of fatty corned beef I'd ever seen. "I don't think so, Philip," I said, hoping that what slender authority I had at the time as the husband of a medical student might deter him. Naturally he ignored me completely and had the sandwich.

In that recovery year he painted continuously, not on physically taxing large canvases but doing smaller oils and acrylics, reduced works that had a distillation to them of all his great late-style humanity in a special burst of richness. Much of that year also was concerned with the picking of the work for his 1980 retrospective exhibition at the San Francisco Museum of Modern Art. This involved exhausting, contentious horse-swapping with the museum's director, Henry Hopkins, a situation filled with old anxieties for Guston, though ones much lessened by the confidence he had in the strength of the recent work. Yet physically, when he finally did go out to California to oversee the

exhibition's installation and opening, he was hanging on by a thread.

In a month he was dead. Around eight one night I answered the phone in Brooklyn and heard Musa's tiny voice: "He's gone! Philip's gone! He's *gone!*" Fred Elias, the radiologist who with his wife were neighbors in Woodstock and who'd had the Gustons over for dinner that night, took the phone from her. "Philip was eating his dessert. Suddenly he put his chin down to his chest— and that was all."

———————

The funeral was the following weekend. Before heading out to the Artists' Cemetery in the center of Woodstock, a number of people gathered for a time in the house. Then, with what seemed like one unspoken will, we drifted across to the studio. In the studio's office corner, on a shelf above a worktable, sat the cardboard box that earlier in the day had contained Guston's ashes before they were buried by Musa and Ingie. The box was an object of dumb amazement, as odd, pregnant, and absurd a plain object in its own way as anything Guston had spent the last fifteen years painting. In a dead painter's studio absence itself assumes a definite form, something almost sculptural, and everyone seemed to walk around the central void of being in the studio that belonged to but never again would be entered by Guston.

Even more remarkable than the box, though, at least for me, was the presence among us of the composer Morton Feldman, summoned down from his home in Buffalo a day or so before.

Feldman, Philip Roth, and I—as per Guston's hospital-bed list of last desires—were to say Kaddish for him in an hour's time. But no one who was in the studio that afternoon was unaware of the poignancy as well as the more than small grotesquerie of Feldman's presence. Over the best part of two decades Feldman had been Guston's closest friend. Up till that very day of the funeral, though, Feldman basically had not spoken to Guston in nearly a decade. There had been a rupture which never managed to become resealed in life. Guston's late style, the move away from abstraction, had alienated the two men.

With bottle-glasses, a low forehead, a sensualist's lips, thick straight hair that streamed toward the crown of his head like hawsers thrown back over the side of a departing ship, Feldman was an imposingly homely, unforgettable-looking man. Yet about him was a charm and a fluency abetted by his thick New York accent and sophisticated aplomb that were tremendously winning. Like his friend Guston he was a jet of hot and various talk, even on that sad afternoon. Quickly and nervously, with real passion, he spoke about caffeine, Kirghaz rugs, his writing an opera with Samuel Beckett, a steak dinner he'd shared with his girlfriend in the local motel the night before. You could see why Guston had loved him.

After Feldman's, a few other crucially close friendships did follow for Guston. The poet Clark Coolidge's playful but dense poems encompassed among other things an encyclopedic knowledge of jazz and film, tossed away as loosely and uncuratorially as a spray of gravel. Isaac Babel entitled a book *You*

Must Know Everything, and in Coolidge Guston found someone who, like himself, truly did. Philip Roth was another close friend, a neighbor in Woodstock who at the time was himself recoiling from the furor over *Portnoy's Complaint.* Facing the fallout over the 1970 Marlborough show, Guston had in Roth's bravery, brilliance, and delight in impurity a good match for his own. A glittering Russian-like tragicomedy was one of the conditions of these late paintings he was making—which Roth got to receive and read back to Guston at their Gogolian stage of calm yet fantastic scandal (and Coolidge and I at their slightly later Chekhovian stage, where a domesticity of the inexplicable obtained).

Yet though Coolidge, Roth, and I each provided Guston with companionship in a lonely yet intensely productive time of his life, no bond ever was as organic, even almost aboriginal, as the Guston–Feldman one. Feldman was the personified linchpin of Guston's forays into abstraction in the fifties. The art world of the time generally viewed Guston as a comer, a prize-winner, a skillful semi-academic style-browser, poised perhaps to yet be important but certainly conducting himself as though he already was. He was not altogether trusted on a few fronts. But friendship with Feldman seemed to bring Guston into an eccentric but sturdy subfold. The composer John Cage was the intriguing magnet that drew first Feldman and Guston after him, Cage's individualist sense of the autonomy and chance elements that could make a Zen-imbued abstract music or painting turn on a dime. There was an immediacy, an *alla prima* quality, to the Cage-philosophy that

appealed to both men for a time. Both clearly were fascinated by time (Feldman's late works sometimes go on for hours); and in the fifties, with war over, instantaneousness happened to be the focus: the lack of interval, the recovery of life, and instinct unburdened by history or even a duration conscious of itself.

Feldman was much more to Guston than just an aesthetic ally, though. About both men was not only a voracious intellectual appetite but a valuable ability to *stretch*. Guston would talk of how Feldman made him really hear Chopin for the first time, demonstrating that Chopin had to be both played and heard as though it was in fact Beethoven—and Beethoven likewise like Chopin. Both men savored food, jokes, smoking. And metaphors. Something about Guston and his work attracts metaphors to it (I have produced my share of them), but none ever were like Feldman's, which were wryly perfect. When he wrote about Guston, Feldman turned poet with a prophetic tinge: "Always aware in his own work of the rhetorical nature of complication, Guston reduces, reduces, building his own Tower of Babel and then destroying it." Or: "As we make a metaphor about creation, it has made a metaphor about us . . . Guston is of the Renaissance. Instead of being allowed to study with Giorgione, he observed it all from the Ghetto—in the marshes outside Venice where the old iron works were. I know he was there. Due to circumstance, he brought that art into the diaspora with him. That is why Guston's painting is the most peculiar history lesson we ever have had."

Yet Feldman finally couldn't sanction the work Guston started producing in the late sixties. In 1978, eight years after the

loosening of their bond, Feldman still was enough on Guston's mind to be the subject of one of the most remarkable Guston paintings: *Friend—to M. F.* (1978).

It is a portrait of Feldman's half-turned away face, a picture composed out of pain plus a startling concentration of simple adult resignation. As still and frozen as a Piero in its way, the remarkable, almost helmet-like Feldman hair is captured in the front while the back of the head begins looking very mineral indeed, that solidified-blood-look that Guston used so effectively. Sclerotic. Feldman was putting a good face on his acceptance of new art, the picture seems to suggest, but the back of his mind was firmly made up. It had frozen against Guston paintings just such as this one.

This would not be the only such portrait of Feldman that Guston would make at around the same time, either. Paintings of coats began to appear. Feldman's father was a garment manufacturer, and Guston delightedly used to tell of long walks with Feldman, the two of them talking about Valéry but being eminently interruptible when they happened to go by the old S. Klein's-on-Union-Square, where Feldman would duck inside to handle a sleeve, to comment on a garment's workmanship. These coat paintings were paintings of Feldman as well—Feldman as *schneider*, the Jewish artist, tailor of the goods. And, like *Friend,* they were done during the men's long estrangement.

On that funeral day Guston's last pictures, small acrylics and inks on paper, were tacked up to the free-standing painting wall that bisected the studio. Feldman, who I'm sure had seen very

little new Guston work, kept glancing over at these tacked-up sheets but was understandably constrained, being in a group of friends and family that full well knew the cause of the chill between the two men years back. Finally, however, he had to go over and look at them (and be seen looking at them), which he did quickly, repeatedly, lightning raids each time. On his first return from them he exclaimed to no one in particular, yet somehow to everyone:

"*Now* I understand what he was getting at!"

At least for me, hearing him say this was to suffer a kind of existential splinter the philosopher Emmanuel Levinas analogizes insomnia to: hearing and seeing what you don't want to hear and see, the intimate hollowness, the seemingly endless vertigo of time coming at you in waves. I couldn't wait for the moment to be done, to pass. No one of course dared to ask Feldman what he thought it was that Guston was getting at—but then he told us anyway:

"I see the rhythm of the images. I see how he arranged them, which ones repeat, the *pattern*. Now I *see* it!"

After Feldman had left the studio to go to his car and on to the cemetery, and my wife and I were getting ready to do the same, Musa walked up to me and said shyly and offhandedly: "Oh, Morty, that Morty. I put those pictures up myself today. Ingie helped me. They're just where *we* decided to put them."*

*This ironic anecdote has yet another layer. According to Guston's daughter, Musa (Ingie) Mayer, and David McKee, the pictures had in fact been arranged by Guston himself. [Ed.]

A year later Feldman wrote an introduction to a catalogue of those same last works after they were assembled for exhibition by the Phillips Collection in Washington. It was clear that he'd held on to his perception of these particular works on that funeral day like a psychological life raft, for he began his published remarks on this very odd note:

> I question the appropriateness of writing about something other than this exhibition. But to write about it, some effort should be given to research. And I have a resistance in talking to anyone who could tell me why Guston assembled these last works the way he did. My attitude is not unlike my father refusing to ask for directions the time we were lost in Hoboken.

He was speaking the most candid truth here: *he did not want to know;* he wanted to know nothing they themselves taught him but rather only something that he already had taught himself. Then, concern for appropriateness apart, he went on to spend the greater part of the brief introduction writing about Schoenberg, Stravinsky, about himself as composer, about Samuel Beckett, Mark Rothko, and Anatolian rugs. These all were modernist figures and ideas and corollaries much closer to him at that date than any of the images in Guston's last pictures—about which Feldman at one point hesitantly refers to as a "mythology," sounding a little like a nervous anthropologist finding himself among cannibals.

These little paintings surely are among the greatest works Guston ever achieved in his lifetime. He had always fiddled with the horizontalities of his paintings, whether they were "of" french fries or skinny legs; and often before there had been an incline, an occasion for clambering up or down such as in pictures like *Ravine* (1979) or *Moon* (1979). Here, though, in these late little pictures, *ascent* was unmistakable. Up slopes as flat and unambiguous as ramps, within cerulean vistas banished of shadows, Guston's whatzits were on the move, journeying within and outside themselves. Suitcases have become teapots (a teapot contains changes-of-state invisibly within itself); big spheres are heavily patched, bandaged, re-armored; a wagon wheel with spokes assumes final custodianship of all those many clocks of Guston's career. Time *rolls*, Guston had discovered. His temperament always was Sisyphean, the hopeless task of rolling a ball uphill, but nothing is pushing these forms ahead other than their own freedoms. They won't backslide, you sense. There is new purchase. The 1980 acrylic called *Untitled,* with the blue-gray, battered ball/head, and its absolutely huge but emptied eye, the pupil high up in regard of the unnamable, seems in retrospect like a blissful going-up to meet fate itself. In this small picture more than perhaps in any other of Guston's opus, the melancholy allegorist had transcended himself.

Yet none of this would Feldman end up noting. He was hardly alone in not understanding Guston's final work, but his disapproval of (and blindness to) what his old friend was up to seems if anything more inevitable—and in some way culturally

proper, culturally clear—than anyone else's. In his sympathy and identification with abstract painting, and with his own methods of translating some of the New York School's visual investigations across channels to his own music, Feldman perhaps was in better viewing angle than anyone else to see what Guston was doing *differently*. Feldman's own musical compositions, one scholar writes, "lack rhythm and dynamic articulation. Durations of tones are slow but free, dynamics constant and quite soft . . . Almost all activity seems to be spread out evenly across the entire range of the instrument. The result is a very flat, uninflected surface, devoid of any sense of dramatic contrast." The music is so subtle, in fact, that some critics have taken to calling Feldman's sections "gestures." Feldman himself once wrote, "The degrees of stasis, found in a Rothko or a Guston, were perhaps the most significant elements that I brought into my music from painting." Moreover Feldman, during the fifties and sixties, notated a number of his own works on graph paper. The duration of the sounds was designated by how much space the squares or rectangles took up.

Time, in other words, was something Feldman strove in his own music to downplay and turn instead into space. This for a composer perhaps is historically eccentric, but it's certainly of a piece with Feldman's own time and milieu. Fifties New York art, whatever it told itself about being in direct opposition to the earlier School of Paris, was in many ways the very triumph of French epistemology that runs from Descartes through Derrida (interestingly a figure who, like Feldman, found convincing spatial

and totalizing cognition in the patterns of Anatolian rugs). Just like this strain of French philosophy, the New York School resolutely gazed inwardly at itself. Rather than seeing outside or representable things, it saw signs, gestures, and proofs of its own sincere inwardness.

Space will always serve this tendency better than time does. In space a Subject can seem to turn into an Object, an object furthermore that seems to want to be a random something as well as a sovereign nothing-but-itself.* Wasn't this exactly what Descartes argued an object *was,* after all: self-identity? In its own casual, unstressed, unideological way, Abstract Expressionism quested to make a subjectivity that was solid enough to replace the pictured object. Is what makes a Rothko or a Pollock universal the formalism, or is it more likely—as the British philosopher and theologian Catherine Pickstock notes—a strange and strained sense of the universal: ". . . Because the individual is all there is, and so paradoxically the individual *is* the universal to the extent that there is nothing 'beyond' the individual."

For Guston, however, there was *plenty* beyond (". . . *then you move into the next,"* he writes in a letter, "*like a strange and new clock, warping Time into becoming a frightening new other place, a land in which there is no rock and no 'nothing'"*)—and in calling forth his strange, funky imagery in order to "re-present" them, he insisted on seeing

*Guston once remarked to me, apropos French structuralism and deconstruction: "If my aunt had nuts, she'd be my uncle."

those things (and himself) *change*. Change most fluidly exists not in space (where its moments are all diced small but ever whole) but in time. Thus it is that Guston's refusal of the abstractionists' "nothing beyond" seems to raise the intellectual stakes here higher than just one painter's change of direction. With each decade since his death it becomes clearer that there was a significant cultural crossroads involved in his heresy, that from Guston modern art received a late challenge someone like Morton Feldman simply perceived earlier and more painfully than anyone else.

LETTER

ROSS—PART I
THE RANT:

Sat–Sept 17 '78

Ross—

 <u>after a new battle picture</u>—<u>a whole series</u>—*I was going to wire (MAILOGRAM) you "The Bomb exploded! I am Totally, Totally, now in that other—<u>other</u> place. Will write soon to explain."*

 But I was afraid the Western Union would get the F.B.I. after me.

 Studio now looks like a battlefield since you've been here— the wreckage—the spoils—the dozens of pictures—images— painted out! Literally—now I am showing myself—TO myself—making concrete as I can, VISIBLE AS I CAN—

much as my gut can stand—as _touchable_—_grabable_—_solid_—
but it always turns out so precarious—Jesus—I could (right
now) grab an ax and WITH _GLEE_ _chop_ _up_ people into
pieces—make those limbs into _chunks_—that I can _eat_! I'm
going crazy—on the edge of madness I think. I feel savage and
absurd—no—not absurd at all—Painting—_creating_—is
BOTH really _impossible-possible_—No more dreaming away—
No more _"moments of innocence"_—Hell—what I'm getting are
hours—days—months—of _knowing_ as I go up cliffs—rocks—
up and down—like a giant and armed bug—hard armored _too_!
No one knows it—but right here—in the woods—I feel like
Lenin or Trotsky—in Zurich, plotting the revolution!—

I say battle-grounds—Yes, the battle—conflict—now is
showing—it's all in the open now—we are in the open now—
we are in the arena—exposed—

What is it? That is showing? I'll tell you—You saw _hints_ of
it—but now it is taking shape—structure (LIKE A PYRAMID)
Pots of paint shown—with dozens of brushes as weapons stuck in
real—real—conflict—fighting off—with weapons—_shields_—not
garbage cans—fighting the abstract part of art—the _not_ visible—
Oh so that's it—the conflict between the real against the unreal.
My God! The things that do not go together—and won't—
must—and yet they do! I was not prepared yet—until now!

Imagine PAINT POTS—FIGHTING GARBAGE
LIDS! INTO A STATE OF METAMORPHOSIS—
TRANSFORMED INTO THE AS YET UNNAMED.

P. S. YOU SPEAK OF HAMLET STABBING THE
CURTAIN!

P.P.S. POTS OF PAINT WITH RED PAINT DRIPPING DOWN INTO POOLS OF BLOOD. BUT IT'S ONLY RED PAINT—LIKE MOVIE CATSUP— SO WHEN ALL'S SAID AND DONE—IT'S ONLY A MOVIE—ONLY A PAINTING!

ROSS—PART II
THE LETTER

. . . So, yesterday, Saturday—after some sleep, I was in the middle of writing these telegramese notes to you that are in the LETTER, when Clark Coolidge came down to see what I was up to—we talked non-stop, of course till 4 A.M. I must have seemed like a raving mad hermit—I had just exploded my bomb and was still in wild eyed thrall. Now—Sunday, I've calmed down a bit—Clark has just left—I'm about to clean up the battlefield here—pick up the mess of dead bodies—but want to get this off to you, before we get ready for Chicago and other duties. I'm worried & nervous about stopping work—now that I've unlocked so many doors—there is so much territory to explore—Oh-oh-oh—can I stand it? Shall I take drugs? Don't know—You say "serious art"—What? I am an alchemist out of the middle ages—I am a necromancer, a laboratory scientist finding ever-new & infinite potential in that world that was always taken for granted—but now it's all open—unknown— We do not know what we thought we knew—Yes!

Well, I better stop this rant!!! I LOVE YOU BOTH— Musa's scarf arrived—your gift—She loves it—will wear it to

Chicago and tells me to tell you—thanks, thanks, and much, much love—tell Ellen she can have my bones when I leave this planet to go in my solar boat—IN THE PYRAMID's TOMB—

Something uncanny—listen—The two books I keep in the bathroom (of the studio guest room where you stay) for on-the-throne-reading are small and have been there for years—One is on Egyptian Mummies and the Art of Embalming—and the other is on Haloes—the use and variety of the Halo in Renaissance Art. What? HUH?. . .

7. IF THIS BE NOT I

The more I saw of the work that was coming from Guston in the late seventies, the more persuaded I became that he had only *seemed* to be an abstractionist during his earlier decades, the fifties and early sixties. That instead, like a Marrano, a *converso,* one of the underground Jews of the Spanish Inquisition, he'd been a secret image maker all along, coerced into abstraction but never grounded there, outwardly observing but also innerly undermining its rituals.

Guston might have been doing nothing more of course than playing out the psychological fugue any artist performs within himself: echoes of old imagery, a recapitulation of career-long themes. But that never really fully accounted for the aerated freedom of the pictures of the seventies, the *spring* they had to them, the quality of escape from a prior confinement.

I don't remember how exactly I put it to Guston, but while talking one night in July 1979 some of these thoughts in fact came out. A couple of days later I got a letter from him:

> *. . . Your sense that the '50s work and early '60s was "forced" to "look" "abstract" was the largest part of the comic-absurd subject. I knew it at the time but couldn't tell anyone . . . The word FINIS really means that things are beginning to be understood. And one's greatest desire finally is not to be merely liked, etc. but to be <u>understood</u>.*

Maybe he was telling me what he thought I wanted to hear, for Guston could flatter baldly—and he'd not unnaturally pooh-pooh his abstract work while in the depths of the cauldron of the kind of different art he was making at the time. But still it seemed to me that the later work threw what preceded it so much into question that he most likely was admitting to some real amount of intellectual relief.

Certainly most of the fifties and early sixties abstractions Guston painted are seductively beautiful, no question. Camouflage invariably *is* artful, aiming as it does for a subtlety that has to be greater than disclosure's. The pictures have an aggregating pulse: mirrored forms, supporting and extending and clumping forms, all redolent of strain and sincerity. De Kooning energizes us with the pictorial curiosity of his abstractions, but Guston sits us down centrally to view the worrying work of moving color and form around.

No camouflage is perfect, though. Even in those classic fifties paintings there remained stubborn hints and shreds of representation as well as personal psychology: a green hood shape here, tendrils that might have been legs, a form suggesting a recoiling head. Was Guston really happy to paint this way? Probably yes and no. Certainly he believed that dilemma and unhappiness were the very subject matters of the paintings; and there always was a kind of flexible *lean* in Guston's abstractions—a leaning-back from the recognizable; and later, in the early mid-sixties pictures, a leaning forward into ash pits of depression, big black blocks of it.

But to lean is not the same as to move. The abstractions are meltingly all of a piece, eventually becoming larger and baggier and softer-edged but still very much held in check. Only when Guston finally was freely broken-out from visual orthodoxies (including his own) did images fall out of him that truly seemed to succeed and incorporate each other; that allegorized, redefined, and separated each other. What was a central pulse gave way to images sliding into motion.

Almost any Guston painting done since 1968 illustrates this new mode of metamorphosis. After working for a year on cigar-box-sized paintings of single or double images, Guston burst out large, for instance, in a painting like *Edge of Town* (1969).

A car is a vehicle that brings you somewhere else. A painting now was that, too, for Guston. This particular car seems to be what's left of his early sixties black monolith-paintings; and it is *only* a car, it appears, because a stem, the steering wheel, allows it

to be. This steering wheel is brushed in with a little white to give depth (Guston still does care for illusionism a little, like a negligent grace) yet the black spare tire and the rear left wheel-well are left blank, outlines.

The hoods-guys are eye-slitted and fabric-seamed (oppositely, complementarily: Guston's natural compositional poise). Both of them smoke big gangster cigars and the left-side figure holds his in the Guston/Dürer control position. Bristling up from the seats are nailed sticks, board, a piece of what looks like red iron pipe (the reds in the picture range from salmon to blood and all five are different). In the blue of outdoors the car approaches a bordering section of rose ground, white over red. This used to be the actual arena of color Guston worked in with his early abstractions, but here Guston has headed his car into such ethereal territory only to make trouble. The picture's bad manners are its very subject. Left on the bottom of the canvas is a bit of white like a movie still torn off, a promise of continuation. And that central red area between the two heads? The seat presumably—but perhaps also the first appearance of the unmasked Guston persona, his will and red-hot determination now, his full head of willful steam.

There were, as well, hieratic pictures such as *Ladder* (1978).

Gaudy as an old movie-palace proscenium, Musa's marcelled head rises like the sun, while on the narrowest strip of black (shadow, for all we know) a ladder is raised against nothing. Over its unevenly spaced steps a single two-soled leg has more or less flung itself in imitation of the sun-goddess. The leg somehow has managed to loop itself through the top two rungs, a feat not only pictorialism and perspective demands but Gustonian enigma too:

shadows don't lengthen both ways nor do ladders stand by themselves. We sense that something has gone deeply wrong here. In the threading process some abrasion has occurred, some blood seems to have been shed, shavings of flesh. There is even the hint back there of another shoe, some kind of obscured busyness, possibly disaster. A leg with three kneecaps never was meant to actually stand, much less climb. Guston's beloved Russian writers, Babel and Gogol and Chekhov, narratively depended on accident or misadventure, and legs for Guston assumed in part the same task: to move the story along.

Or, in the case of *Green Rug* (1976), stomp it to death. The woolliest, most specified, most manic Gustons always took me the longest to get used to; I dealt more easily with the uninflected, melancholic ones, the ones that looked like they could decoalesce back into abstraction with just a little more scumbling, a little more grisaille. Yet exactly the most "zealous," over-the-top paintings like *Green Rug*—funky, shaggy, ugly—may yet turn out to be the most important masterpieces of them all. If any Guston picture ever could be a museum-gift-shop refrigerator magnet, this surely is the one. It is an infinitely concentrateable image.

During the fifties Guston was most personally connected with the more literary of the New York School painters: Motherwell, Rothko, Newman. To look back at the crowning abstract works of these artists—Newman's *Stations of the Cross* series, Rothko's DeMenil chapel in Houston, Motherwell's *Elegies to the Spanish Republic*—is to see them each calling up some extra-visual lubrication to ease his way in producing sensual works with heroic intentions. But in a painting as radical as *Green Rug,*

Guston grows his own references. No less literary than his friends, Guston explored stories of his own making—the seraphic, the pathetic, the scarified, the hilarious, the outrightly iconic—in the guise of french fries and spaghetti legs and wild sproutings of kneecaps. The heroics and spectacles of inwardness were forfeited.

Green Rug was the picture Guston personally chose to serve as the cover for the catalogue of his 1980 San Francisco Museum of Modern Art retrospective, and all his heedlessness is here. Physically tall himself (though his head usually was bowed, his shoulders slumped), I'd frequently see Guston instinctively straighten to full height in front of his least "acceptable" canvases—which themselves as often as not were defiantly vertical in layout. It was almost as if Guston, before them, was reminded in some physical way that with these he had truly "drawn away."

Green Rug is the homage to Piero's *The Flagellation* that Guston wanted to accomplish lifelong. Not just because of the whip, but because its elements are so very separated, profoundly removed. Two legs have been commanded to dance, putting down any number of quick, flattened, ankle-turning steps so permanent that they've turned not only into dance-studio markings but actual shoes.

The legs themselves are notably horrible. There are no rounded thighs in late Guston, no calves, no ankles, no toes: the legs always are *arm-legs,* which here seem to have groped their way into the very painting (while one offstage might very well be holding the whip). One of the allegories of this picture might well be that although unseen hands make paintings (with brushes, a soft small kind of whip), legs are what carry us from here to there, from then

to now to when. To move narratively in a space that promises no expansion—whose forms literally step over each other—is to invoke, instead, time. The steps on the floor indicate positions of priority and succession.

In late Guston, fringes (or many-footed bugs, or legs, or eyelashes, or hair, or tassels, or french fries) reoccur as a regular formal need to add thin lines to a volumetric solid. This "fraying" (here, I guess, it would be *flaying)* quality of individual escaped threads is something Guston's sense of the anti-perfect repeatedly stressed. The legs bristle with a few stray spikes of hair. The whip, languid with authority and terribilita, needn't do much more than hang there, the almost phallic shape of its handle shining above mock-sweetly like a Renaissance putto. In Guston's first youthful paintings the Klan held the whip, but in this late one the whip holds itself. And as nauseating as the stringy hairy legs are, maybe even more so is the narrowing cone of blackness between the legs. Guston's fiercer allegories use black a great deal, a black soaked with the india ink of the cartoonist or like Shostakovich's heavy chords, his parodic dancing through the flames. Titling this picture *Green Rug* puts a *sorry-too-late* domesticity over the whole scene that no one will credit. The narrative here is of everything about to blow. The rug shakes with the shuffling of the feet, and we can tell it will not stay on the flooring very long, that the flooring, too, will at some point give way, be beaten down by the footsteps dancing to the whip's imperative.

———

With paintings like these Guston challenged more than only abstraction, I think. He challenged Modernism's very faith in the idea of art-historical evolution, as well. Evolution, David Sylvester notes, has gone hand in glove with the faith that a work of art

> must affirm its existence as an object and that subject matter was incidental to its proper purpose. Its essential slogan was Maurice Denis's affirmation that a picture, before being a representation of something or other, was a flat surface covered by colors arranged in a certain order. It was what Baudelaire had been saying fifty years earlier when he proclaimed in 1846 that a good picture had a meaning even when you were too far away to identify the subject.

If everything about a work of art can be kerneled in its will-to-form, it follows that every period for an artist is as good as any other, necessary in the filling development that is underway. In this way evolution *itself* becomes a kind of abstraction. Yet Guston seemed to resist both.

Why? Had the various modes of abstraction failed him, or was it vice versa? Was he after all what his peers grumbled about: a style-shuffler, a mind that just could not be made up? One of the second-generation New York Schoolers, the painter Jon Schueler, wrote in his diaries (posthumously published as *The Sound of Sleat*):

Phil Guston loved Piero della Francesca, but he wanted his beauty to be of his time, and he was deeply hurt, I understand, when his friends, his brothers, his fellow artists said, You, Phil, with your figurative paintings, with your success, you are a traitor. You are selling out. You are not with us. You are not seeing. The story goes that he changed then. He started all over again. Depending on how you look at it, that was a very brave or a very weak thing to do.

And of course when he *stopped* painting abstractly, his friends, true believers, gave him a hard time all over again.

The whole anti-evolution/false abstraction issue was one I found difficult to clarify in my own mind, too—until, that is, I'd finished the catalogue essay for the 1980 Guston retrospective in San Francisco. I sent Guston a copy of the manuscript, and the next time I came to visit I found Guston and Musa drawing me aside rather ceremonially almost as soon as I walked in the house. They both remained standing as I took a seat. They almost walked small circles around each other, like people waiting for a train or for a loved one to come out of surgery.

They wanted me to know, Guston said, how thrilled they both were that I had gone ahead and written in my catalogue essay that his name originally had been Philip Goldstein. He'd always felt awful about the name change, he explained to me, and now at long last it was time to admit to it in public. Both he and Musa

agreed that he'd only done it in the first place to appease Musa's parents in advance, to make himself more acceptable to them.

This I'm sure was true as far as it went, though of course there's always more to such a thing. The practice of Jews changing their names to more Gentile-sounding forms usually is viewed as a sociological response to prejudice and to the pressures of conformity. Guston's left-over leftist iconoclasm certainly included religion: he recalled Yom Kippur dinners and mock-Seders with the Rothkos that involved shrimp. All the same, with Yiddish habitually and liberally thrown into his speech, he had no problem seeing as well as presenting himself as a doubt-ridden cerebral Jew painter.

To any name-change there is a deeper, more existential level. Watching and listening to Guston that afternoon, it suddenly dawned on me how Guston could have been and also not been a shamming, less-than-committed abstractionist during the fifties. He had spent a lifetime involved in the cycle of maskery and then self-disclosure, I realized. To change a name is both to overvalue and undervalue the I, the specific identity that we hide behind and yet also are known by. Jean Starobinski writes that the mask makes the person behind it feel the Self more intensely—if for no other reason than the pressure of the mask is upon his skin, his Self.

The hood the painter wears in *The Studio* (1969) is therefore no accident at all. The Ku Klux Klanny hoods originally returned to Guston's hand with the 1968 Chicago Democratic convention, an outrage against violence hearkening back to the Los Angeles pictures he did as a youth—but why they *kept* appearing in his

paintings for years after that, well after his rage had cooled, rose from another source. The hoods became for Guston what the *pulcinelli* were for Tiepolo: the first of his remarkable casts of touring masks, players, to appear over the next ten years— *reminders* of Self, *extenders* of Self. The eye-slits of the hoods in the hood-paintings, although expressively flexible, always are vertical; through them the masked Goldstein trained his eyes on other things than himself. Yet at the same time, without the ingrained tendency to mask (and its advantages), Guston never could have managed to paint the powerfully self-revealing pictures he did over the last ten years of his life.

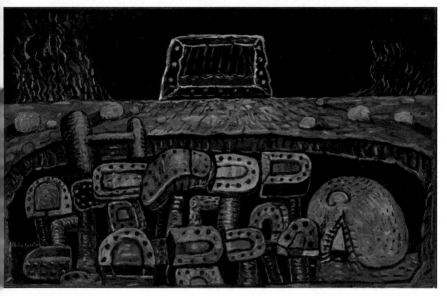

Pit, *1976*

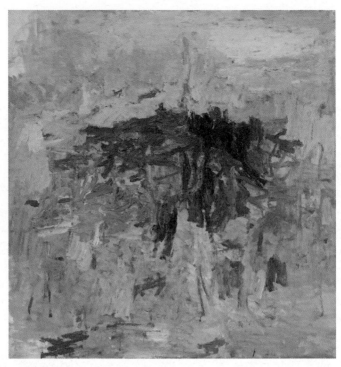

For M, *1955*

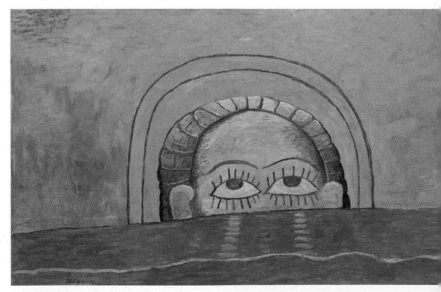

Source, *1976*

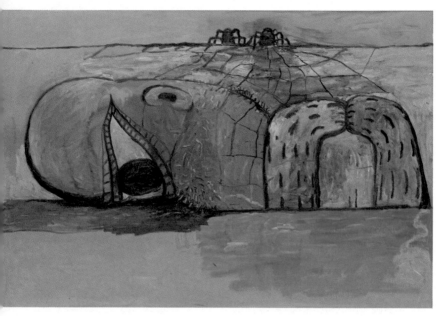

Web, *1975*

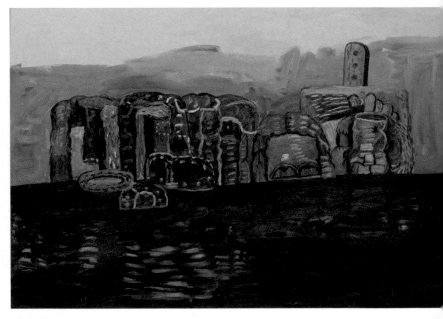

Wharf, *1976*

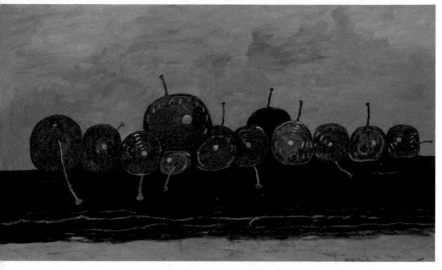

Cherries, *1976*

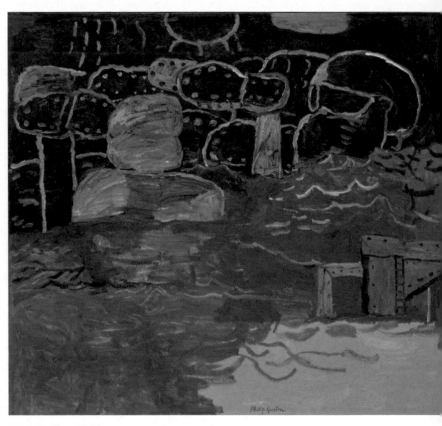

Blue Light, *1975*

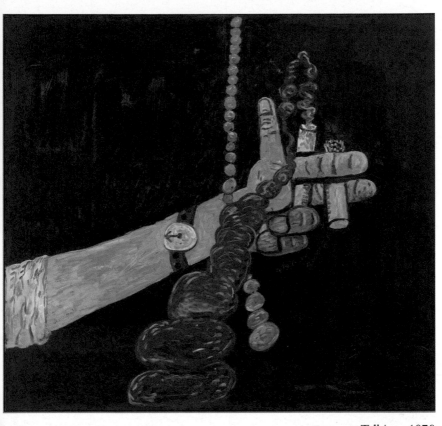

Talking, *1979*

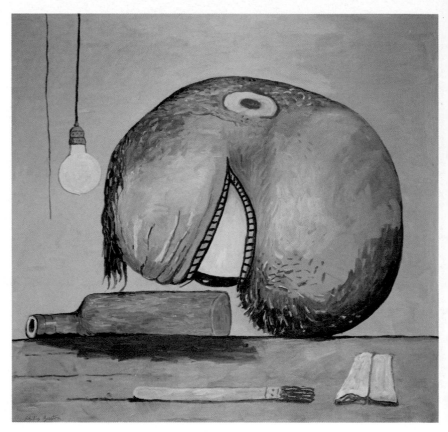

Head and Bottle, *1975*

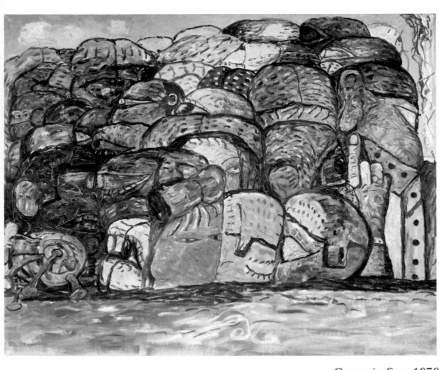

Group in Sea, *1979*

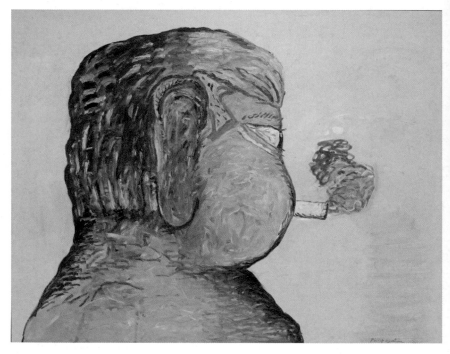

Friend – To M.F., *1978*

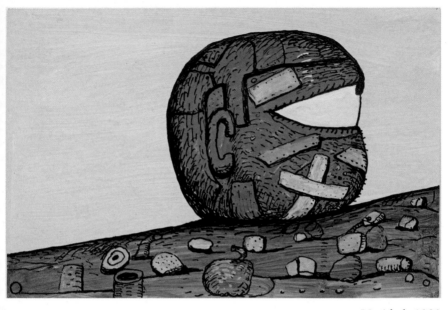

Untitled, *1980*

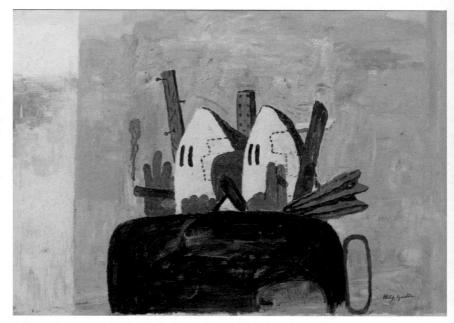

Edge of Town, *1969*

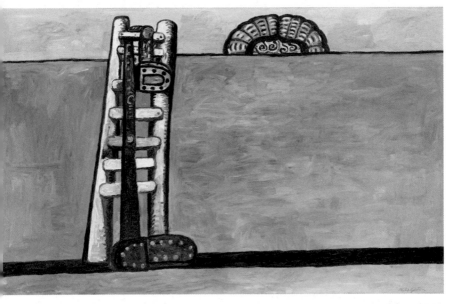

Ladder, *1978*

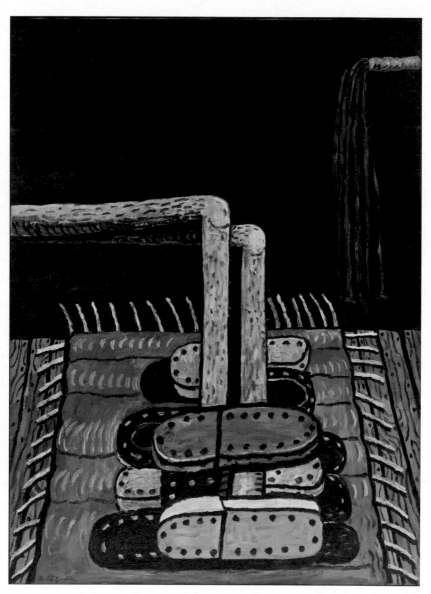

Green Rug, *1976*

The Conversion of St. Paul

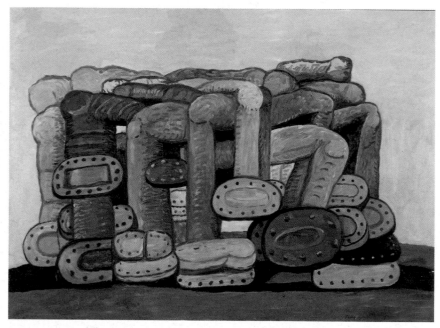

Monument, *1976*

8. ACTOR

Visitors to Picasso's studio were reported to have felt as though they'd been invited to a circus. The inventiveness and play and manipulation in different media created something like five ever busy rings before them. When I mentioned this once to Guston, his response was: "Well, here it's just strictly clowns."

Picasso's figures—his saltimbanques and Benin masks and mistress-models—certainly "are all actors," writes Guy Davenport, "wearers of masks, mediators, like Picasso himself, between reality and illusion." The same with Braque, Klee, Roualt, Ensor, Guston. And yet apart from the shuffling of reality and illusion, the theatrical in the hands of these artists may also indirectly clear up some of the confusion and entangling paradox we have about representation and abstraction in visual art.

On stage, representation essentially boils down to two modes: mimicry and exhibitionism. Jonas Barish's extremely useful book, *The Antitheatrical Prejudice,* reminds us that

> If exhibitionism has tended, generally, to provoke less indignation than mimicry, the reason is plain enough: mimicry involves conscious deception, nearly always (so it is thought) for wicked purposes—for why would one *want* to depart from truth and nature except to injure others—whereas exhibitionism, merely carries truth to extremes.

But in visual art this formulation somehow has been reversed. With its fidelity to appearances, mimicry is sanctioned, exhibitionism not. The enduring knot of art and religion, a conflation which by now we hold almost subconsciously, may be behind this. Always there have been religious qualms about the exhibited as opposed to the innerly felt, for instance the Protestant antagonism to liturgical pomp. "Did the church," Barish summarizes, "need to assume visible forms at all, or might it exist solely in the hearts of believers?"

As it so happens, Guston arose—and then escaped—from the heart of one of the most deeply Protestant art-histories ever seen: the Abstract Expressionists. The New York painters made external Works that testified to inner Faith, the gestural not aimed outward but urging a painting to go back down beneath its paint, to mean no more than its deepest soul. Abstract Expressionism sought

purity with a certain portion of Puritanism. Painters like Rothko or Newman and Still, with their neo-sublimes, recapitulated Plato and Rousseau in finding that, as Barish says, "truth lies not in concrete particulars nor in what possesses the accent and the beat of life, but in the silent, invisible essences that underlie it." For Puritanism shares with Romanticism (Barish again): "a belief in absolute sincerity which speaks directly from the soul, a pure expressiveness that knows nothing of the presence of others. It takes as its models the guiltless folk of the earth, who 'know not seems': the peasant, the savage, the idiot, the child—those in whom the histrionic impulse remains undeveloped."

Guston on the other hand constitutionally mistrusted all essences. Nor would he be denied a single instance of "the accent and the beat of life." And his histrionic impulse, once he let it out, developed quickly. But to do so, he had to work directly against his New York School habits. He had to make himself stubbornly *in*authentic.

This in itself has led to its own confusions in placing Guston's challenge, for there is a single prevailing mode of artistic inauthenticity in our time: the Duchampian/ironic school. The first baffled reception to Guston's painting found shelter there, the art world calling Guston a neo-Pop artist or cartoonist. This he never was. Duchamp, and the Pop artists, and the pastiche-ists like Rauschenberg and Johns all reveled in sorting-out the accepted into patterns of unacceptability: distortion, cool shock, ironic high-spirits. They were after effect as well as élan. But Guston tacked toward celebrating the crap of life not for its own

ironic sake but as the ever-present still life that surrounds the embarrassingly, even tragically human. No Duchampian object ever is tragic. Many if not most of Guston's objects, even the most hilarious, are.

Barish recognizes that artists themselves distrust the histrionic, going as it does against the impulse and dream of "creating something permanent, fixed and exempt from the ravages of time, well-wrought urns and mosaic saints. Inert matter they can force to do their bidding; they can impose their shaping wills on it, stamp it with their signatures. But how to subdue human beings in the same way, who have wills of their own?" Guston himself, for instance, wrote to me in 1977 about his

> double sense of an "itching," febrile need to make a masterpiece * (* On so many days, I feel this to be a truly stupid ambition. But it is there—to be reckoned with.), and equally as strong (and THEN melancholy) realization of this total impossibility. Then follows this numbing sense of the inutile. Ross—what is creating—this forming anyway?!! A treadmill? Try to stay on it—throw off the dross—make the architecture and content impossible to take apart—not even 1/8 of an inch padded. Lean. Yet working with images as I am attempting, makes all so unimaginable, chaotic, as well as baffling. And so unpredictable, which is why that 1/8 of an inch change of forms & spaces transforms the meaning. I know I'm going in circles talking to you this way. (Musa, in the next room, just said "Did I hear a big sigh?") Well—

perhaps one should be satisfied just to stay on the treadmill—to remain on it—maybe that is all that is truly given to us. My god! A lifetime spent—to have a few innocent moments. To baffle oneself—to come in the studio the next day and feel—I did that? Is this me? To catch oneself off-guard?

"You want a clock? Here's a clock!" Oh, if it were only as direct and as simple as that!

This last bit referred to a story Guston told about teaching at Boston University. With her classmates, one of his more talented graduate painters was working on a mural for one of the B.U. cafeterias and having a great deal of trouble with a clock she was trying to do: the stylistics of it, the trompe l'oeil, perhaps even the Guston homage involved in it. She worked and reworked and overworked this clock until Guston, observing, couldn't stand it anymore. Grabbing a brush, he loaded it, painted a circle, then two hands within it:

"You want a clock? Here's a clock."

Guston repeated the story fully aware of its implications. "*Here's a clock*" threw a short punch at the self-consciousness of modernism itself. It made a comment on the post-Magrittean correspondence between images and verbal cleverness: OK, this *may not be a pipe . . . but this is a clock.* It spoke, beyond anything aesthetic, of plain human impatience. Maybe most of all it was turned subtly toward the word *want*. What you want you may have, it offers, if you give up the false anxieties of painting.

Guston, both fascinated and repelled by Mondrian, liked to say that the almost mystical system of abstract purity Mondrian entertained had to be completely right or else completely wrong. Right or wrong didn't terribly bother Guston—"completely" did. Even to accept the best Mondrian paintings as valid, this harsh and inhuman totality and maximalism would have to be factored in.

The kind of ambiguity found in de Chirico was more to Guston's taste. As a depressive, objects asserted a powerful attraction for him. Around the figure of melancholy in Dürer are many untouched objects, each pregnant with meaning undisturbed by use or misuse. Yet Guston also knew that representation could not only be of recognizable things. The unassignable, vaguely star-shaped, spool-like thing that is called Odradek in Kafka's allegory, *The Cares of a Family Man,* comes closer to the images Guston populated his pictures with (as well as to the ruins of melancholic allegory Benjamin and Guston so well understood):

> One is tempted to believe that the creature once had some sort of intelligible shape and is now only a broken down remnant. Yet this does not seem to be the case; at least there is no sign of it; nowhere is there an unfinished or unbroken surface to suggest anything of the kind; the whole thing looks senseless enough, but in its own way perfectly finished. In any case, closer scrutiny is impossible, since Odradek is extraordinarily nimble and can never be laid hold of.

In the mid-seventies a book by Leo Steinberg, the art historian, proved to be a great inspiration to Guston. Steinberg's monograph, *Michelangelo's Last Paintings*, concerned the two frescoes of the Vatican's Pauline Chapel, *The Conversion of St. Paul* and *The Crucifixion of St. Peter*. Guston mentioned the book again and again in 1976, and it's not hard to imagine how attentively and identifyingly Guston must have read Steinberg's précis of these great and unconventional frescoes' neglect and later redemption:

> ... The Paolina frescoes were felt to be failures—void of grace, dissonant in composition and color. Of the two paintings, one seemed too strident, the other too rigid, and both equally uninviting and bleak. And then, after centuries, Walter Friedlaender in 1934 would see the pictures as reaching a "scarcely understood pitch of spiritual abstraction."

Steinberg judges the re-evaluation of the Michelangelo frescoes upon four main supports:

> ... the recognition of old-sage style (translation of the German *Alterstill*) as a distinct psycho-stylistic phenomenon; second, the definition of "Mannerism" as a willed departure from the ideals of the High Renaissance; third, a re-interpretation of the "abstract" or non-figurative objective in Michelangelo's paintings; and fourth, a changing conception of the nature of representation as symbolic form.

What I think struck Guston in the Pauline frescoes (apart from the identification he'd naturally have with the pictures' negative reception and centuries-long neglect and misunderstanding) were two things primarily. The great legs of the horses in the St. Paul fresco seem to me the most likely source, even quotation, for the greatest of all the Guston-leg paintings, *Monument* (1976), now in the Tate.

And, more important, there was Steinberg's deduction that Michelangelo's own face appears at least twice in the Crucifixion fresco, once younger and once as an old man. "He paints himself in!" Guston exclaimed to me. "After all, who the hell was *he* to get off scot-free?"

Steinberg gets to the very heart of self-portraiture when he writes:

> As the fresco in its entirety embodies simultaneities of then and now—the Crucifixion as a historic moment, the meditation upon it and the presage of its commemoration in the Tempietto—so the artist, too, if he is indeed present, may be portrayed in the full span of his moral history.

For Guston, too, some image or other of his own self needed to be in most of his late paintings. Only by that was a certain plasticity of authorship and philosophical comedy maintained, a "moral history." The Guston self-portrait never is heroic or even pathetic. What it is, is *unsparing*. Hair wild, face cut and patched after shaving, wild-eyed, gluttonous, a tuberous head. Where

another head appears, Musa's usually, in paintings like *Web* or *Wharf*, Guston's self-presentation is either shrunken by shame or made bloated by guilt. Sometimes it is not even awake, conscious. In the seventies he did a number of pictures of himself and Musa in bed, separately or together, remarkably vertical or horizontal that hearken back directly to drawings by Ensor as well as to a certain allegorical tradition Guston knew all about: Panofsky, in his *Life and Art of Albrecht Dürer*, points out that dramatic representations of Melancholy often show a woman asleep by her distaff combined with a man asleep at a table or even a bed.

But the "spiritual abstraction" that Friedlaender talks of in the Pauline frescos of Michelangelo, that which Steinberg sharpens to "moral history," was precisely where time and self-depiction intersected for Guston. He saw his own working through time as his work's *only* continuity, one beyond style, influence, and even aesthetics. To be *the same person* painting year after year came to seem to him more impressive and mysterious even than the physical objects that were the paintings themselves and the images thereof. Goldstein/Guston, subtle colors and hairy ankles, all of them emerge unchecked from the *same* life of art. What could be more wonderful and scandalous, more histrionic than that?

Guston made himself one of the actors in his own play—as every self-portraitist will—because he knew the play, the life of art, was allegory, removed yet unbearably personal at the same time, raucous as well as devastated. And though no one I ever have known has suffered dilemma and doubt more overtly, fluorescently, outsizedly, cossettedly than Guston did, he at some point stopped making his suffering do what it had done previously in his work.

While his friend Mark Rothko's torments were sublimated into subtle, harmonic beguilements; and his friend Morton Feldman's into ever more wiry, purer, finally almost silent forms—Guston in his work finally suffered *non-absorbingly*, more in response to what he could make seeable-to-himself in images than from a reflux of personal pain. In this way he was not that much different from Signorelli or Domenico Tiepolo or Goya or Van Gogh. Some of these images simply stick up like bookmarks out of the book of Guston's life, with that kind of tracking purpose, but others are almost not to be seen for what they are but instead as a signature of time passing, past, and passable.

Philosophy occasionally describes a division between "thinking *of*" and "thinking *about.*" Guston's late theater of self-portraits, representing and allegorizing himself working through time, perhaps gives us a framework for images in contemporary art that blends a painting *of* and a painting *about* in a useful way. Only defined and separated by the time it took to do them and the amount of doing it took to posit them in time, Guston's many late paintings are like the individual stills of a flip-book or captured frames of a movie. Bound together by the painter's bravery and freedom within time to show himself, the images themselves liquidly change form and meaning but never birthright. All of them are born in the rich precincts of personal responsibility and raw change.

LETTER

A B O U T *your new work—and when is it "finished"—
oh-oh—that is the real and only question. Of course you are
absurdly right—the work says "let me be, I'm only a painting or
a book—let me live a little." ALONE—WITHOUT YOU.
But is it that I think I am through (I may be only exhausted)
and go to bed and 4 A.M. (when you awake) cannot sleep—
clothes back on—looking at the picture—scrape it out—take big
house-painters brushes, smush it all up and feel relief. Start
again—<u>what a relief</u> to face nothing—recently in this state, some
other kind (I wish I knew) of seeing takes place—the ravaging
hunger to see something I haven't seen before takes over. It must
be appeased. Ross, if age has given me something, it may be, (I
think) a small electronic time box—built in—won't allow me to
rest, until something—anything—a scribble is put down before I*

*think it out first. Oh, how I hate composing! Ross, I don't think
I am a painter—at all! I am, I think, a medieval alchemist in a
frenzy.*

*Jesus, this is turning into something fancy-shmansy. I don't
mean it to be. We are just comparing notes, aren't we? I love
your statement ("it sits there, ready to be overhauled: smug
bastard"). Yes, that is the way it is. You are not confusing to me,
may I say—I know, "bupkes" as well as the "internal vertigo."
I'm not boasting. It's been my life.*

*Ross—I don't quite agree with you that it is a "superior sort of
gall—to make a work—to assume the connection between maker
and made—to make such elaborate fortifications against Time."
(Your words.) My bone to pick is a tiny one—maybe a cockroach.
But here it is—at least with me—(and I take the liberty of
thinking, with you, too). It is not gall—no, it is shame—shame
to be an artist—shame to create—Embarrassment—a huge
dose—to be an artist—assume the role of a maker—suddenly I
go into reverse, and feel as you say—maybe it is gall. You—we—
deal with forces—no matter what form they take—we release
them—they are governed by such generous laws—of such
magnitude that either we do not comprehend them or it makes us
have daily breakdowns trying to. Our damn and unavoidable
minds, habits of analyzing—God says, "don't fuck around with
my stuff boys—You just love, adore, cherish what I have made."
But, the next hour, in fact, right now, my mind, my desires have
changed. I WANT TO MAKE. Somehow (I remember once*

remarking to you) I think I've always felt that creating is an evil thing—Satan's work—Maybe therein lies the shame. What?

May your hospital check-up turn out fine—I fervently— hope—let me know?

What is a vacation? I should know? All I know is, you take all the sludge, as you call it, with you. For myself—I know Florida caused my breakdown. So don't ask me. Ask Kafka— who says (as you well know) "art, for the artist, is suffering, only to be released for further suffering." This is not gloomy—better to know the facts of life. No? My mind is going in circles right now—I better stop—

Do take a short vacation—hear? Then come up here—where there are no truths—only blind stabs, and it will be joyfull—

(In the margin was this:) *I am 2/3 asleep. It is 4 A.M. Overlook this crappy letter.*

[1978]

APPENDIX
THE PHILIP GUSTON/ ROSS FELD LETTERS

Edited by Josh Rubins

The friendship between Philip Guston and Ross Feld grew out of their correspondence as well as their long talks in Woodstock and New York. Between 1976 and 1980, they exchanged at least thirty-five letters and cards. Guston's daughter, Musa Mayer, found Feld's letters, most of which were typed, in her father's desk after his death. Feld treasured Guston's letters—all in burly, looping handwriting, often covering both sides of several sheets of lined, legal-sized paper—for the rest of his life.

Feld judiciously interpolated a half-dozen of the Guston letters, and excerpts from a few more, into the elegantly structured text of *Guston in Time*. Although Feld's relationship with Guston was an important part of the manuscript, and a turning point in Feld's life, he kept the primary focus on Guston's art—and so didn't include many of Guston's most personal letters,

or any of his own letters at all.[1] Also, Feld may have felt uncomfortable about quoting Guston's ecstatic responses to Feld's insights. This, for example, is Guston writing to Feld in mid-1979:

> *Your thoughts are the only things that has happened to me this year of any import. I'll shout it right out—you inspire me to paint again! To get out of my circular brooding, my dwelling on my ills and crotchets.*

The letters—other than the long excerpts used in *Guston in Time*—are presented below in chronological order. Read in sequence, they offer up a dynamic record of the ideas that informed Guston's late work, and a remarkable dialogue between artist and critic, painter and writer—comrades, in Feld's words, "perched on some cold, black Edge."

───────

The correspondence began in October 1976 with Guston's note of appreciation for Feld's "singular" article in the May 1976 issue of *Arts* magazine.[2] Guston declared that he felt "great

─────────────

[1] Feld's third novel, *Shapes Mistaken* (1989), is dedicated to Guston's memory. In an autobiographical essay published in connection with his fourth, *Zwilling's Dream* (1999), Feld wrote:

> To see Guston's faith, his zealous delight in the work tumbling out of him, even to see his loneliness and need and frequent black disgust at how ignored this remarkable work remained, was the most powerful artistic experience of my life then and since.

[2] The note is reprinted in its entirety in Chapter 4 on pp. 40–41.

recognition"—as if "we knew each other and had had many discussions about painting and literature." Guston's response was understandable. Unlike most critics of Guston's work of the 1970s, Feld saw in these "cartoons for the chaos" neither social satire nor a self-indulgent excursion into comic-strip crudity. The artist's stunning 1975 paintings, Feld insisted, were a powerful confirmation that Guston was not merely breaking new ground but arriving at something both intensely personal and profoundly original, comparable to Beckett's achievement in literature:

> The triumph here, and an unmistakably major achievement in Guston's whole opus, is a triptych: *Blue Light, Red Sea,* and *The Swell.* . . . In each, three uproarious levels contend: at the bottom, a flesh-pink flatness; up top, a black and gelid night of nothingness; and between these, a torrent of breathtaking red, blood-colors, out of which stick divers ankles and shod feet, an occasional head—all borne away. Can we still possibly think politics? What his New York School contemporaries told us about more with their lives (and deaths)—the onrush of despair—Guston, in these paintings, has made plain and manifest. A ravening tide like this, gathered here and there by blacks and pinks into tiny brutal waves, just isn't caught by anyone but the most subjective of painters—rather than something observed, it's something *faced.*

Feld answered the note, the men met for coffee in New York
City, and Feld evidently gave Guston a copy of his *Plum Poems*
(Jargon Society, 1972). In March 1977 Guston sent Feld a postcard
announcement of a two-part exhibit at David McKee's gallery,
adding a handwritten message: "I would be pleased if you can see
the new work—best, Philip Guston." On the bottom of the exhibit
announcement Guston wrote "letter on OTHER SIDE" with an
arrow. This note appears on the reverse side:

Mon.

*I've been wanting to tell you for months now, how much my
wife & I enjoy your Plum Poems—it is always on our table—to
read – re-read. They are lean—meanings reverberate—but my
main pleasure (if it can be separated) is your most plastic feel in
your words.*

Philip Guston

Feld attended the exhibit, of course, and was soon seeking out
an opportunity to see yet more of Guston's work.

4/21/77

Dear Philip,

*The good doctor McKee, when Archie Rand and I were at the
gallery last week, kindly pulled from his pocket and spread out
on the desk snapshots of the work that'll be going west in
May—and we looked and spread our jaws both and shook our*

heads in astonished, sort of helpless amazement at 45 of these beautiful monsters.[3] Forty five!

Rand called me up the other day to report a sort of kishka-gnaw: "I've got to see those paintings before they go to Los Angeles!"

Now, my wife and I thought we might come to see you and your wife in mid-May sometime (Ellen has to work and can't easily get away before then), but in light of Rand's pleas and my own equally strong thirst to see these stunning bulvans, would it be possible for just Rand and I to come up for the day on Tuesday, May 3 or 10? Possible? If not a good time, please tell me.[4]

Hope your little trip down to D.C. was pleasant. And that your wife is feeling better by the day. I look forward to meeting her.

So drop me a note, if you can, and then, if it's O.K., I'll be back to you with final arrangements. And if not, not—another time.

Be well,

Best,

Ross

Feld's visit to Guston's home and studio quickly followed – the first of many. Musa Mayer, writing about the otherworldly quality in her father's work in the late 1970s, recalled: "During this

[3]Archie Rand. See above on pp. 36–37. [Ed.]

[4]Echoing his description of Guston's new paintings as "beautiful monsters," Feld made idiosyncratic, affectionate use here of the Yiddish word "bulvan"— commonly translated to mean an oxlike and oafish or boorish person. [Ed.]

period, Ross Feld often came up to Woodstock to see my father's new work. A slight man, possessed of a quick wit and a powerful tenderness, he understood this strangeness."[5]

June 19, 1977

Dear Philip,

What else to possibly say except that it was a deep <u>refreshment.</u> I'm never otherwise with people whose company not only slakes at the moment but promises even more, as though each hour we talked was like the building of a bank balance that would pay interest. Strange—that I felt so completely happily at ease and yet at the sight of the work I sung inside so electrically, wired, that I was all snags.

What you are, in a sense, Philip, is a Martian—a creature brought new to it all, but Kierkegaard's Martian: the one who's been down here before but now uses rotation to make what he knows into what he doesn't. Every painting speaks to that, so every painting frees.

I was delighted to meet Musa and see her looking so well; her graciousness and character made Archie and I feel right at home.

I'm still off-balance about the painting you gave me; Ellen, I don't have to tell you, is ecstatic over it, touched, and proud. Her kiss of thanks rides this note.[6]

[5]Musa Mayer, *Night Studio* (Knopf, 1989), p. 182.

[6]Guston had presented Feld with one of his many small "cigar box"-sized paintings. [Ed.]

It's a little formal, this—but artificiality, in the beginning, isn't all a bad thing: it allows me to plant and seal over a few feelings that you ought to know. So know them.

I'm going to see you soon, again, if you'll have me. The trip up was a breeze and without difficulty. It'll be my personal little commuter route: the road, Cervantes said, is better than the inn.

Be well, Philip, and the same command and regards to Musa.

best,

Ross

———

Sunday—July '77

Dear Ross,

You may think that your letter to me has fallen into a deep hole here in the Catskills. It was a joy to receive. I love all you say—but—I wonder if I deserve your lovely generous remarks. I mean, I find myself wistfully wishing that I were, or more precisely that I could think of myself so, as you describe.

This is to be a doleful letter—a dirge. Since your visit, I've seen no one save check-out girls at the A&P. Musa, it seems to me, is progressing slowly but it will be a long pull—memory and the naming of things lags. Doing household chores made me lazy—I ate—slept. Laziness turned into lassitude and melancholy, finally solid despair. Old friends, of course, but I never seem to learn. I console myself—notions about the ancient Angel of Forgetfulness. Preparing for the new and as I've just

barely started making images again—thinking I had so much capital to draw on but no—now comes the dismantling—the desert again—my appetite for what I haven't yet seen.

I've read "Years Out" slowly, savoring it.[7] Your scrupulosity is delicious—the close looking—hearing—smelling, atmospheres, weather. And treading delicately among your humans and their relationships as though in a mined field. It is all attention. I enjoyed and admired it greatly. I wanted you to know this.

Are you around these parts this summer? Seems that I remember your saying that Ellen's parents (or relatives) are around Poughkeepsie—which is about an hour or so from here. It would be marvelous to see you and chat.

Please write me if this is so. Are you writing?

I'm very pleased that you and Ellen like my little token-painting. That it sits well in a good home makes for a kind of completion.

Next time, just bring yourself (and Ellen, if possible) as the gift—tho' it is true, I was overwhelmed by the bagels and lox — lasted the whole week!

Archie [Rand] has written me a most friendly and too flattering note.

When you see him, tell him I should like to write him soon. I have that miserable habit of writing letters in my mind—not on paper. And it is all I can do right now, starting to want to paint again.

[7] Feld's first novel, published by Alfred A. Knopf in 1973. [Ed.]

For the moment then, my best and warmest greetings.

Philip.

P.S. If you have time, it would be great to hear from you.

————

Aug. 3, '77

Dear Philip—

Can't reach you on the phone, and I'm afraid this will get to you by Friday, earliest.

Tell me (call) if it's no good—but Ellen and I are going to visit her parents this weekend (6–7, Aug.) and we've invited Archie Rand and his wife to come along.

Would it be all right if the 4 of us stopped by Saturday and spent the afternoon with you and Musa? No lunch, no dinner—no hosting of any kind, Philip, do you hear? Ellen's parents will be expecting the four of us for dinner—so just the afternoon to see you.

I repeat: no host-stuff! Just talk and walk and kvetch and birds in the trees.

Again, call me if this is inconvenient.

Otherwise, see you around noon, Saturday.

Love,

Ross

————

Mon. [August 8, 1977]

Dear Ellen & Ross,

 Wonderful to see you both & have the pleasure of your visit. Only trouble—it went too fast for me. While we are still munching on <u>all</u> that food you brought up, Musa and I keep trying to remember each part—<u>what</u> was said—talked about, <u>when</u>, etc.

 Still look ahead eagerly to your promised visit, Ross, with Ellen on a weekend or you alone during the week—bus or train—either way it's best for you. I do want to show you the new series of paintings—with Musa and myself as subject matter—These may add or connect with that picture of last year that you liked. I don't know.

 Always exhilarating talking with you.

 Love, Philip.

———————

Aug. 22, 77

Dear Philip,

 Some fairly good news: I wrote to the editor of <u>Arts</u> magazine about my idea of doing a one-picture article, and he just wrote me back saying that he'd love to do the piece. He's already planned an issue of just this sort of one-picture-to-one-article pieces in January, but he said he'd put my piece in the next issue or perhaps the one after that. That means Feb. or March—which sounds good to me, since that gives me a mid-December or

mid-January deadline: no great need to rush and do it wrong. He (the editor, Martin) sounds very enthusiastic.

So we'll give it a try, yes?

Did Sloman take a picture of that painting?[8] If I could get a print, that would probably help me during the times I'm not at Woodstock looking at the painting direct. The more I think about this, the better an idea such a piece seems to me.

Had a wonderful time a few weeks back with you both. I can't wait to see the new work, so will try to come up in the next few weeks; I'll let you know when, O.K.?

Hope you're both well; my love to Musa.

Ross

[An additional note from Ellen Feld is added in handwriting to Feld's typewritten text.]

Dear Musa and Philip—

I also want to tell you what a wonderful time we had visiting you. I felt so comfortable talking with you both. It was just terrific.

Best to you both,

Ellen

[8]Feld wanted a photograph of *Wharf* (1976), the subject of the proposed article. Steven Sloman, an artist and photographer, made a photographic record of much of Guston's work of this period. [Ed.]

Aug 30–77

Dear Ross,

 So good to hear from you—and the good news that you are writing the piece you spoke about. I can't tell you how <u>eager</u> I should be to read such a piece.

 Yes—Sloman made a photo of the painting—no problem— I'll write him to send you (or me) a print as soon as possible. He can be terribly slow but he will do it pronto in this case.

 Now I am so anxious for you to see the new work—it is all lined up for you to see. As I mentioned to you, many pictures have to do with Musa and me—related really to the one you are writing about and it would be good, I think, for you to see them. Other new ones, are new images (naturally growing out of the ones in the show). I feel like I'm telling a vast story, both forwards and backwards.

 So—take yourself—hop a bus—or train—come up any time you have the time. It will be a joy to see you—Just let me know—no big warning necessary at all—

 Love to you & Ellen.

 Philip.

———

Sun. [10/31/77]

Dear Ross,

 Finally the photo has come—at least you can glance at it while you write.

For me, it was a wonderful afternoon spent with you—the other day, talking over essential matters. It remains with me. Hope you are well. I hope to see you soon—Love to Ellen & you.

Philip.

Nov. 26, 1977

Dear Philip,

I'm working hard, but am also a strange person: busy, busy, I also get damned sluggish and try to do maybe at the most two of the autonomic responses: think & breath[e], perhaps—those are nice—but past them? Talk? Not much. Read? Excessively. Communicate? Oh, the barest trickle—embarrassingly little. So you work up there and I down here, and perhaps over some mid-point like upper Rockland County do the groans admix, just so we both know we're serious, right?

Your story: "You want a clock? Here's a clock!"⁹ I am only slowly as I begin this new book, realizing how much the story impressed me. I am writing so far without imagination, my favorite wrench—but I know whereof I speak in this book so intimately that nicety of design seems an a posteriori concern.¹⁰ I've always owned a funnel, but this time it's upside down. [Feld's drawing of an upside-down funnel appears in the

⁹Feld recounts Guston's "Here's a clock!" story—about trying to paint without painterly fussiness—in Chapter 8 on p. 95.

¹⁰Feld was then working, and would continue to work for several years, on his second novel, *Only Shorter* (North Point Press, 1982). The title comes

margin with a mass labeled "stuff" coming out of the wide end. Ed.] *It's curious and astonishing to me, to work this way. All the leash I give myself. We'll see.*

Are you working? By now, if you are, there must be new things to be seen. In a bookstore the other day, I saw a copy of Artforum, *I think it was, in which some guy or other was writing about drawing—conceptual confetti mostly—but in a footnote said something to the effect of: "For the last ten years, Philip Guston has been practicing a technique of drawing that depends not only on the artist's own satisfaction but calls into play other sensory dimensions we normally don't understand"—or something like that. Then it went on: "See my article, Philip Guston: Delirious Drawing," in the June 1977 issue of Arts." Do you know about this? I didn't— I still don't. I'm going to the library next week and nose around.*[11]

Thanks for the b/w of "Wharf." That morning I spent with the painting—talk about delirious!—I find now that what I

from Beckett's *Malone Dies* (". . . and die one day like any other day, only shorter"). The subject matter with which Feld was so intimately familiar was the lives of cancer patients in their twenties and thirties. When it was published, Larry Kart wrote in the *Chicago Tribune*:

> Death and the threat of death certainly loom large in Feld's book, and we care about what will happen to his characters. But "Only Shorter" is really about paying attention—the sleepy kind of attention we pay each day to ourselves and our worlds, how that attention can shift into a different gear when we know that the next day may be our last and, above all, how this novelist pays attention to the way life and fiction interact.

[Ed.]

[11] "Philip Guston's Drawing: Delirious Figuration," by Kenneth Baker, later an art critic for the *San Francisco Chronicle*, appeared in the June 1977 issue of *Arts*. [Ed.]

thought were notes were the neatest little scratchings I've ever made—I could publish them as is. I'm not going to—I've got double that to say—but feel good that I'm going to work on so fully articulated a formation. What we must agree on, Philip, leaving aside questions of modesty and self-discretion, is that you are the <u>only</u> painter on which it is even remotely possible to write intelligently, with some point—since you are the only painter now who is working with the intermediaries of thought and form. This comes to me more sharply every time I pick up the Dore Ashton book, look at the photograph of "Wharf," or—best of all —look at the painting and drawing on my walls. When I think about your work, the thinking itself receives some complementary enfolding: the shape of the critical thought finds itself aligning with the work by equal valencies. Mental meets mental; numb meets numb. It's not the case with anyone else today.

Drop me a note and tell me how you both are? Winter should just about be full upon you now, yes? Ellen and I talk maybe once a week about going to that party and then to dinner with you both—how fine we felt! Then just getting together, you and me, for lunch two days later—so good it could become habitual. We miss you both; I hope soon to put myself together, once I'm done with the second chapter of my new "thing" to enter the world of those-who-are-not-me to maybe come up and pay, as Menachem Begin would say, "wisit."

Be well, both of you. We love you.

Ross

[At the top left-hand corner of this letter Guston wrote "Hello Ellen!" and drew what appears to be a delicate necklace, a reference to the simple chain that Ellen Feld nearly always wore, and which Guston often commented on. Ed.]

Dec 7, 1977

Dear Ross,

Your good letter came while we were in Boston and so it wasn't till last Monday that I got it—read it <u>avidly</u>. HUNGRILY. What a marvelous and so open a letter to get from you! I only wish I had words to even approx. yours. I'll try—

Yes, I've been painting a lot until I went dead about a month ago—I think, because of certain duties pressing on me. Teaching, for one thing—thank God I shall be through with it by April. I jump into it heart and soul—DAMMIT!—argue—fight— explode—and then total exhaustion afterwards.

I promise myself—silence—or give just a "little"— "save" myself, survive, at least, in some retreat. But no—I am too much of a zealot to do so and go on, publicly, slaughtering and butchering the J. Johns, the Rauschenbergs, Motherwells, et al—Modern Amer. Art in general—(Just like the ancient zealots of Judaic times). To sweeten the Boston Univ. Teaching kitty, took on talks at M.I.T. and Harvard and it was a complete shambles. (These two inst. are dominated by dogmatists—<u>Greenbergvilles</u>![12]) A ruin really—since they weren't "lectures" (who can do that?) but sort of

[12] The reference is to Clement Greenberg (1909–1994), the most powerful and influential art critic of the postwar period and a major champion of Abstract Expressionism. [Ed.]

bull-sessions; give and take questions & answers; I'd get questions like what do I Think of the new art, like "Holography"—(what the hell is that?) & MIXED MEDIA and why shouldn't modern art be part of its time, etc. You can imagine easily I know what my responses were. I would sputter angrily all fire—then feeling guilty, snowflakes come out of my mouth. What am I?? A fire and brimstone preacher—a tortured Talmudist—God knows! Enough of that –

So I did complete finally a huge painting about a month ago, weeks on it—much scraping out, until at last, the blessed release—painted in a few hours. I wanted <u>everything</u> in it—<u>all</u> I know—knew! Now in looking at it and (even to you—risking immodesty), I feel it took me 40 years to do—yet feels to me as if it was thrown off—just like that. <u>Now</u>, of course, that old friend of mine—that familiar sense of failure <u>settles in</u> (and, oh yes, while I "think" I am my own best looker, I am also my own best critic, as secretive as <u>that</u> is). Also, there are other pictures between, I mean, leading up to this huge plastic chunk of a machine I have described above—which you haven't seen and my greatest pleasure, it goes without even saying it—would be the joy of a visit from you— not only to look—but to talk with you—(as you say—about that wonderful lunch in the village and being all together at dinner after Jody's opening)—that it could become a <u>habit</u> and how I wish it <u>would!</u> We too think of our burgening (sp.?) relationship with such need, sweetness and growing necessity. The few miles between us will have to be eliminated in some way—If I have to do anything about it. I miss being with you very much.

I like <u>so very much</u> what in your letter you say about— "intermediaries of thought and form" and—"the thinking itself

receives some complementary enfolding: the shape of the critical thought finds itself aligning with the work by equal valencies. Mental meets mental; numb meets numb." How exquisite and precise! I will dwell on this thought—savour it. For it connects (how?) in some startling way with my double sense of an "itching"—a febrile need to make a masterpiece and equally as strong (and then melancholy) realization of this total impossibility. (* On so many days, I feel this to be a truly stupid ambition. But it is there—to be reckoned with.) Then, follows this numbing sense of the inutile.*

Ross—what is creating—this forming anyway?!! A treadmill? Try to stay on it—throw off the dross—make the architecture and content impossible to take apart—not even 1/8 of an inch padded. Lean. Yet, working with images as I am attempting, makes all so unmanageable, chaotic, as well as baffling. And so unpredictable, which is why that 1/8 of an inch change of forms & spaces, transforms the meaning. I know I'm going in circles talking to you this way. (Musa, in the next room, just said "Did I hear a big sigh"?)

Well—perhaps one should be satisfied just to stay on the treadmill—to remain on it—maybe that is all that is truly given to us. My God! A lifetime spent—to have a few innocent moments. To baffle oneself—to come in the studio next day and feel—"I did that?" Is this me—To catch oneself off-guard?

"You want a clock? Here's a clock!" Oh, if it were only as direct and simple as that!

I should, I guess, end this rambling on—outside it is all white—naked limbs of trees—and a certain Siberia, too, of the

spirit. Winter has come—we settle in. A Chekhov gnome may have entered my vessels as I write—it is dusk—there is also the wind blowing snow—a spaghetti sauce on the stove—my first highball of the day. Perhaps this accounts for my rambling & torn sweater of a letter. No order at all.

I am happy you are writing. Your new ideas for the novel really fascinate me—it would be foolish of me to say "Eagerly look forward to"— "Fervently anticipate" and etcetera— — — —Enough to say right now—wonderful!—To play "Foxy Grandpa"—I say, <u>no matter</u> with or "without imagination" as you mention. I love "upside down" as well as "astonishing to you to work this way." Let me show you our true funnels: yes— there are 2!

[Here Guston's handwriting exploded into calligraphy and he drew two large funnels, criss-crossed. One is right-side up: a dark swirl of steaming "STUFF" goes into the wide spout, and out come a few pallid, sad drops at the other end. The other funnel, like Feld's, is upside down, with only a few sharp, twinkly atom-like fragments going into the narrow end. Hurled out at the bottom is a heap of shoes, limbs, and eyes, again labeled "STUFF." To the right side of this drawing Guston wrote: "'tho I love your funnell [sic] drawing too! and we love you too. Both of you— Philip." To the left is a "P.S."—"So come up soon—or I shall visit you!!!!!" It is illustrated with a drawing of a hatted figure tooling along in an old-fashioned car, trailing behind him what appears to be a long scarf, lifted by a breeze. Ed.]

Friday—[December 1977]

Dear Ross,

The Blanchot piece (translated by R. Howard—not Ashbery— my mistake). I feel somehow relates to our conversation the other day. Perhaps, you already know it and have it! For me, it has been a strong moral influence ever since it appeared in '59.[13] I would like to know how you feel about it? To steer one's life—in art— without being too much of a victim—not to feel too much ashamed is I think our common, I mean the given, problem? Who, in his right mind, would not want to give it all up altogether—but of course we are not in our right minds but "besides ourselves." And, above all we truly are not in control. So, the choices we make in order to put at least a temporary end to the torture of vacillations that finally can kill. And it does. And so, there is the treadmill. An exact, noble, yet grinding symbol.

What a wonder it was to me to be with you for those hours the other day—when you placed me firmly on the Bus. The trip back was filled with thoughts of our little and short conversation. I babbled much too much! For this—forgive. As I know you will.

Everything you said, the snippets you cited of your coming piece on "Wharf" were sweet to my mind. Naturally, I can't

[13]The piece that Guston sent with this letter was a brief 1953 essay on Beckett's *The Unnamable* by the influential literary theorist and novelist Maurice Blanchot. Richard Howard's translation was published, with the title "Where Now? Who Now?" in the Winter 1959 issue of *Evergreen Review.* [Ed.]

wait! I know that it will be a gem and that I shall treasure it. As I do your last article on my work. I suddenly realize we had not met yet! How strange it all is.

It always takes me days to recover from a N.Y.C. visit, and so I haven't really read your piece on Archie, but have only scanned it—in bed. Fascinating! But I still need another 24 hour sleep to read it in some kind of rested peace.

A bad knee has developed and I go about with a cane. Where did this come from, dammit! The snow and mountains look fine to me right now and who knows, we may simply stay here. Remember Kafka's aphorism?

"Remain still—don't move—don't just leave the room—the world will roll to you by itself, to your chair, to your feet." Something like that. Please write—come up—if your time allows. Whatever! Much, much love to both of you—

Philip

———————

1/17/78

Dear Philip,

The cold? The warm? Which? Where've you been? Ellen and I tried calling you a few times right after New Year's Day, but didn't get an answer. So, now:

A happy and healthy New Year to you both, a good, solid, big-bite year!

The phone calls, see, were a holding action against the letter I owe you. And that letter wasn't going to come until now, and here's why: just at the end of last week, against the teeth of the deadline, did I finish "Guston's 'Wharf.'" Kept worrying it, cleaning between its toes, combing its hair, finally let it out on its own. I think it's a good piece; what more I have to say ever again in an art magazine is unclear to me; it's not long—6 or 7 pages—but I think it tells the truth. Anyway I couldn't for the life of me manage to deal with you, Philip, in the second person while hauling you about four hours a day in the third. Maybe I shoulda tried: it might have been the queerest letter ever written: "you (he?) a? the me (I mean, one) does did?. . . "

So I simply clammed-up. Which doesn't mean that I didn't get the Blanchot essay. It's fine, and especially toward the end, he goes a little incantatory, getting B[eckett]'s rhythm into his prose as well ("He is the man who has surrendered himself to the incessant . . . ") B.'s self-erasure is absolute—but maybe the way to get into that is to find the surviving flotsam, which seems the opposite tack to Blanchot's. The French, they really are a funny race: Blanchot has so little interest in Molloy and Malone Dies: I can only think it's because he doesn't get the jokes.

Steven Sloman came through for me, with the transparency, and it was beautiful. I'd been calling him over and over again, getting nervous in fact that I'd finish the article under the wire, then have it held up because Sloman wasn't home to get my calls and supply the negative. But finally I did get him—and he told

me about Roberta Smith's article in *Art in America*.[14] I thought it was a good, meaty piece, and was delighted to see all the plates. Who knows, Philip, maybe at least the eyes will open; the souls, well. . . .

All's well here. My new book writes itself. Ellen had an interview for medical school here at Downstate in Brooklyn, but we don't know what was decided yet. Otherwise, we're hoeing our rows as usual and can't wait to see you both.

I'm not going to send back the *Evergreen Review* unless you tell me to; I'll return it in person, O.K.?

Be well, both of you (Philip—how's the knee?), keep warm—and if you've been gone, welcome home; if you've been home, also welcome home.

Ellen sends kisses to you both.

love,

Ross

———

Feb. 2, 1978

Dear Ross,

Your Xeroxed article was here with the seagulls when I got back from N.Y. and if it has taken me some days to write you

[14] Roberta Smith, "The New Gustons." *Art in America*, Jan.–Feb. 1978. [Ed.]

(my first impulse was to call you and scream—My God—My God—how __fantastic__ the piece is!) it was only that I wanted to re-read it many times—savour it—roll it around on the tongue of my mind.[15] *Well—what can I say—which part can I really pick out (I could only quote and read it all back again—to you!)—to let you know how much I treasure it—its inspired thought—its intense looking—its wisdom—knowledge of the real impossibility of art. (Possibly, art can only be a "longing.") Yet it __does__ exist—the scrupulous and delicate way to write about a painting! To speak of gratitude on my part is not to say much really—it is more that it is my great good fortune to have your eyes—mind—on my work and to write about it with such fabulous insight. You know I am not one to flatter—you say that you scrubbed its toes—combed its hair—, etc.—Maybe—but what you really accomplished is an __OPERATION__—like a surgeon you opened it up (the picture) cut into its nerves, organs, blood system and glands. Nothing less than that. Allow me to say that I feel so close to it that it is almost "uncomfortable"—like an invisible organism in the back of my head—an X-ray eye and mind. "Sees all—knows all." I am stunned! I don't believe it! Related to your remark on the phone that your new novel is writing itself and that you were now writing for __yourself__—I must tell you that my strongest feeling about your piece on "Wharf" is that aside from pleasing yourself, you were*

[15]Feld's article – "Philip Guston's 'Wharf'" – appeared in the April 1978 issue of *Arts*. [Ed.]

writing it for me—not a magazine—but for me to read—a
letter, of course! And, the only way! All parts are so wondrous—
Of course I love "whatzit"—the parts on the issue of
autobiography is great.[16] *(Pity, we have only words to express*
our feelings—I mean—on my part.) I love "Numb itself"—
"Just as location leads to meaning, meaning is already on its
way to the mind." (This makes me feel laborious—didactic—
heavy handed on this point, in the Harvard piece I enclose.) I
have a tendency to "explain"—you do not—you give—give
and take your chances. I console myself saying, well—Ross is a
writer—in command. Not the least of the piece's glorious
qualities, is that just below the surface—the surface of a deadly
seriousness, is a certain kind of humor that I love—feel close
to—"Just us guys limbs"—The fixing on the glass—ice in the
highball—The "Joan Crawford" look—many other parts have
this inspired tone which I think fits me like a glove. And it is all
so fused—no part of the piece can be taken apart. Having made
the operation you sewed up the picture—back again—seams—
sutures not to be seen. And we are left exactly where we were in
the first place. Of the masters that I adore—and perpetually
tantalizing—unsolvable—I can't for the life of me tell where the
seams are—meaning and structuring are that invisible.

[16]Referring to the persistent strangeness of Guston's images, Feld wrote that "it is perhaps the least appreciated and most meaningful achievement of Guston's late work to have restored a sense of the 'whatzit' that's been missing from painting since Picasso. . . ." [Ed.]

The quote from Shakespeare is new to me—How wondrous it is—so there is nothing new is there?[17]

I wish you and Ellen were here so much—<u>will you give it some thought?</u> There is so much more I want to say about your article—I'll save it for when we see each [other] next—Also, I'm happy as a sand-piper about what you said about how your new book is going—!!!

Please write soon—?

a salty kiss to both of you—

Musa & Philip.

P.S. [over]

For what it's worth, I enclose both the Harvard notes and a sketch for what I hope to say in Minn. I'm almost ashamed to do so—they read like explanations to the I.R.S. about my "profession"—about my tax returns—but I'll risk it—knowing you will understand.[18]

[17] Feld wrote, "by continuing his private narrative of whatzits, Guston hounds the predicament of metaphors that are able only to land on other metaphors, of the terrified and aghast mind trying to corral itself by reflection. In *Troilus and Cressida*, Shakespeare understands precisely:

> For speculation turns not to itself
> Till it has travell'd, and is mirror'd there
> Where it may see itself.

[Ed.]

[18] A transcription of Guston's 1978 lecture at the University of Minnesota was published, as "Philip Guston Talking," in connection with a 1982 exhibit at London's Whitechapel Gallery. The text differs in many respects

I'd be happy of course to meet your friends in Minn. Be there in Feb. 27–28.

At times, when I walk along the beach carefully going around the mass meetings of the gulls and pipers (are they massing themselves for a minion? (sp?) I visualize a "high-rise" of mammoth size of my tangled legs—made of concrete—wouldn't that be stunning? An echo to the Mayan Pyramids on the Yucatan side of the Gulf.

I've heard it said that the mind goes pulpy—like an overripe mango—if one stays too long down here. Possible. Right now, for me, it is a nowhere—a new void—is this what is called a vacation?

love, Philip

———————

3/6/78

Dear Philip and Musa,

We've got a genuwine hotcha piece of news: Ellen's been accepted into medical school—and right here in Brooklyn, at Downstate Medical Center!! Even as I write she is taking my blood pressure and hocking me to fill out a Blue Cross form.

———————

from that in the ten handwritten pages Guston sent to Feld. Some of the differences may be attributable to difficulties in transcribing from a recording. For example, in the transcription Guston quotes Franz Kline as offering one of the better definitions of painting: "He said, 'You know, painting is like hands stuck in a mattress.'" The handwritten notes make it clear that what Guston actually said was: "'Painting,' he said, is 'like hand-stuffing a mattress.'" [Ed.]

Needless to say, we're much relieved; I didn't let on to you, but had she not got in here in this country, it looked likely that we'd leave for Mexico or perhaps Belgium: four to six years of what we both, in unguarded and candid moments, looked upon as exile. BUT WE DON'T HAVE TO DO THAT NOW. We're a little numbed by the news; it was so unexpected, considering that she's tried with no success before and the fact of her age. But she made it!

I have perversely and unwillingly responded to this glut of good fortune by going into a modified tail-spin with my work— attention shredded a little, I guess. But am getting back to it. As the man said, "life is one damn thing after another."

Philip, if you've looked for ARTS—the March issue—and found it, you now know what I too discovered. My piece ain't there. ARTS does this regularly to me—screw me like this: they must view it as an alternative to night baseball—and when, in high dudgeon, fluster and splutter I called the editor on the phone he promised me, in his best fruit-juice voice, that the piece is already being set for the April issue. So I hope. Gramsci: "Pessimism of the intellect, optimism of the will."[19]

How was Minneapolis? The draft of the remarks that you sent me was effervescent—but of course we're talking about for me, not the Vikings and cornhuskers out there. What kind of response did you get? I'd have loved to be there.

[19] The phrase is attributed to Romain Rolland, but Italian Marxist and radical intellectual Antonio Gramsci (1891–1937) popularized it as a slogan, using it on the masthead of the journal he edited, *Ordine Nuovo*. [Ed.]

Last, because I don't know quite what to say, is how happy I am you liked the piece. It _was_ a letter—a communication—of course. You gave me the picture; the least I can give in return is the impress. I think I will take a little rest from "art writing" now; after the "Wharf" piece I can't quite think of anything else to say.

We are daily happy that you're missing the swinish weather here, though yours doesn't sound all that hot itself. But soon'll be spring, whoop it up among the daisies, Philip will introduce his pet seagull to the Woodstock natives and Musa will rebrick all the walls of the house with shells. Listen to the high spirits! Hear the desuetude!

The doctor sends her love. We miss you both a great deal.

love,

Ross

6/27/78

Dear Musa and Philip,

Stubbornness against stubbornness: you don't answer the phone, and despite two weeks of daily calling, I don't write. But here I am, crying Uncle! Why haven't I written? Terrible machine, the typewriter; abhorrent to me by this time; I've finished the _Harper's_ article (who knows if they'll even take it), am coming to the homestretch on a first draft of my book— perhaps I'll be finished by mid-August—and doing _Kirkus_

reviews to bring in the bread. . . write something else, English?
God forfend![20]

 But I have to know how you both are. How is your gut,
Philip, and how is your head? Now that Ellen is not working for
the summer, what we'd like to do some weekend is come up, if
that's all right. We miss you both tremendously. The hope is—
sounds very official, no?—that after all the shmazzerie with
Boston, then the hospital, then the depression, that the summer
has taken over for you both, and that you're both well and
securely home.[21]

[20] Feld's "hack" reviews of fiction, poetry, and criticism for the pre-publication
book review journal *Kirkus Reviews*—he wrote hundreds during the late
1970s and early 1980s and remained an off-and-on contributor for nearly
twenty years—were in fact challenging, learned, and prescient. *A
Confederacy of Dunces* was only the most well-known of his influential pre-
publication discoveries. (The "mix of high and low comedy," Feld wrote, "is
almost stroboscopic: brilliant, relentless, delicious, perhaps even classic.")
Indeed, as a poetry critic, Feld temporarily transformed *Kirkus*. New
sections were added to embrace his expertise on Montale and Mandelstam
as well as Americans of every school. (His longer essays on poetry appeared
in such journals as *Parnassus*—which in 2002 established an annual award
for criticism in Feld's name.)

[21] Guston suffered from a variety of serious ailments during this period. Musa
Mayer recalls him treating eruptions of ulcer pain with vodka and milk.
Night Studio, p. 179. In his response to Feld's August 2, 1978, letter, Guston
referred to having suffered a "breakdown" brought on by his "vacation" in
Florida. In Chapter 5, Feld writes that Guston "had numerous what he
called 'breakdowns.' During the time I knew him he checked himself once
into Johns Hopkins, another time Massachusetts General, looking for and
finding ulcers and fatigue (masking alcoholism and manic-depression)
. . . " [Ed.]

Yesterday I thought for a little about the drawing show: October? Only one word came to mind: splendid, it's going to be absolutely splendid.[22]

I don't remember ever being quite so tired. I feel lately like I've been holding a pencil with even my feet—the longueurs of hackdom! I have one more piece promised for the summer, something for the <u>Saturday Review</u>, then I'll rest a little, maybe the book will be done—who knows? It's been hot and sticky: a grand time for kvetching.

Send a short note, then, and keep me up to date, who is so woefully out of it. Ellen sends hugs and a kiss each to you both.

love,

Ross

A few weeks later Guston sent Feld the long letter—beginning "Just completed a picture (Picture?)"—that precedes Chapter 6.

8/2/78

Dear Philip,

My groggy end of the phone conversation we had yesterday was, I've got the impression, about as light-bestowing to you as a bucket of river silt. What's the man <u>talking</u> about? Best as I can make out, this was what I meant to say: that we got it into our

[22] *Philip Guston: Drawings, 1947–1977*, David McKee Gallery, N.Y. [Ed.]

heads to come up Thursday, stay till Saturday; of course with your family coming, we put it off. Putting it off, and making an alternative date. Even garage mechanics can make alternative dates—why can't I? Next week, as I think I mumbled, I have to go into the hospital for my semi-annual tune-up; then Ellen insists we recover from that—and one or two other crazinesses— by whisking us off for a week or so. When we get back, Philip, on your doorstep there we'll be. Ellen, unflappable as she ever is; me, in my newly becoming tatters.

Is it me? Certain things I can't seem to get a fix on. Does this happen to you, when you finish (but, you see, your honor, the man's not even <u>finished,</u> just resting on a ledge) something? Sade wrote on toilet paper in prison; I seem to be writing on air. Love me, love my routine. Do you know that I didn't understand one word of what was said at McKee's that night? This is perhaps what's called exhaustion—or afterburn, or good old kosher (glatt) anxiety.

I sleep long, well-like sleeps at odd hours; I pop awake my usual four o'clock in the morning, then have no book to go write at for the moment (it sits there, ready to be overhauled: smug bastard); Ellen is sure that a week in the Blue Ridge mountains will be spiritually beneficial. Who knows?

Anyway, if I seem confused—and confusing to you (and God knows, I really don't know anyone else who seems to be enrolled in vaguely parallel tizzies)—believe me, it's <u>bupkes</u> compared to the internal vertigo.

I wonder finally if it isn't a superior sort of gall: to want to make a Work, to assume there is some connection between maker

and made, to then feel pouty when the Work decides it needs a little privacy of its own, to make such elaborate fortifications against Time. Was Kafka wrong, to skitter always at the margins? I don't think so. To float free in absolute guilt: not so crazy a tack, is it?—and he _knew_ it, I'm positive he did.

Work, Philip. Did I get across to you at McKee's how wonderful you look? Work, and in two weeks you'll have the mixed pleasure of scraping the sludge with me, and we'll both be batting at flies, jumping to conclusions, being wrong, and other millennial joys.

A kiss to Musa, we hug you, and I'll see you in a little bit.

love,

Ross

P.S. Ellen is reading Wolfflin; will this help her in surgery?[23]
P.P.S. What exactly _is_ a vacation, anyway?

[August 1998]

Dear Ross,

It was so good to receive your letter! Such a long one, too.

Full of how you feel—felt—even predictions of how you are going to feel. REMEMBER, a sufferer can only understand a fellow sufferer—so your talk falls on eager ears. Believe me. Who knows what was said at McKee's that night. I know that I chatter like a chimp. When I come to N.Y.C. and on the train

[23]Heinrich Wölfflin, _Principles of Art History_ (1915). [Ed.]

back, am full of guilt—what did I say—do—hurt people's feelings, and so on. _But_ the hell with it! Trouble is, it takes me several days to get over it.

[Guston filled the left margin of the first page of this letter with a vertical drawing of suspended, linked leaves and fruit—a cluster of grapes, a bulbous strawberry and, sitting below, a large, partially eaten piece of watermelon. Below the drawing in large letters he wrote: "NO ONE TO TALK TO, BUT, YOU!" Most of the remainder of this letter—in which Guston embraced much of what Feld wrote but disagreed with the idea that making art is a "superior sort of gall" ("It is not gall—no, it is shame")— appears as the final section of _Guston in Time_. Guston also responded to Feld's news about his post-Hodgkin's semi-annual visit: "May your hospital check-up turn out fine— I fervently hope—let me know?" Ed.]

Love & kisses to you both—Tell Ellen—Wolfflin has everything to do with surgery—tell her all about it when she is here—He is nothing but surgery—See you soon—Much love.

Philip.

––––––

9/13/78

Dear Philip,

Things are so unusual now that Ellen's begun school—the other day she brought home a box of bones to study, and not from

a chicken either—that we are just starting to settle into some routine, some tentative regularity. So the silence from here. Anyway, I'm a slow thinker, and I had to think about what you showed me in the studio last time (what a fine time, by the way, we had with you and Musa—we both felt so good afterwards. The painting you gave us: we are still so excited about it we're usually at a loss for words when we look at it.)[24] *So, slow to congeal, here they are, the thoughts:*

I had not expected—I mentioned this to you in the studio— you to have slewed so far out. If the paintings were merely fantastic, punishing, and grotesque, I wouldn't have been quite as disturbed.

You're floating now somewhere beyond answers, it seems. The pressing, rolling, vacuuming, flinging of these forms: the <u>edgeness</u> they have, which in a way is much scarier than the abyss, which at least assumes itself a nullity. The pictures seem to ask: what if you jumped off the world and <u>didn't</u> find just nothing? Suppose you found another <u>something?</u> Like that mouth, or box of swords, or spindly machine, or ashcan lids. What then? Especially if the other-sided something was nothing you could immediately—or perhaps ever—classify. Positioned on this edge, held in place by the most delicate and frightened air, the images seem barely holding on— suction, at most—and yet perversely (because there's a touch of perversity in these paintings even more radically strainer-ed than in those that came before; it's not like lighting a match around a bomb, but lighting them inside a place in which there <u>might</u> be one, if it

[24]Guston had given the Felds a second painting—one from the Rome series of paintings in the early 1970s. [Ed.]

were only not so dark and we could see: hah!)—yet perversely they inch forward to make little occult investigations, brave and—to me, who's probably a sucker for this, anyway—consoling. I cannot get out of my head at least ten of the canvases; at the moment, it's the shoes on the tiny floor that's perched on some cold, black Edge.

It makes me think, Philip, as I always think when I look at your work—and I mean all of it, Forties onward—that I've never seen serious art before now. Truly serious art.

I'm back at work on my book: next draft. You mention now and again "a moment of innocence" and then wonder if all the shit is worth it. I'm wondering, truly now, if there's even a moment. I've been thinking about it this last week. I see no innocence whatsoever. Reality is used as a shield against itself: Machiavelli couldn't do better. No one is more surprised than Hamlet when he stabs through the curtain (re, our Hamlet talk); the artist knows that what's a stage without a curtain, that you don't want to rip it so bad it discloses everything, the bare, ugly stage. Instead he jabs, makes little tears, swarmings, investigations, deaths, anxieties, cruelties: as if many and continually will hold off an answer, the last thing he wants. So where's the innocence in that? Nothing is more carefully cultured in me than my recklessness, which someone else wouldn't recognize probably if I held it up before his face. I can't find even a moment, honestly.

I'm sending you back your halo booklet[25] (E. loved it. Gave her a cross-section of art history, which is perhaps the only way;

[25]In a later letter Guston refers to a small book on the "use and variety of haloes in Renaissance Art" as one of the books kept in his studio's guest-room bathroom "for on-the-throne reading." [Ed.]

she sends her thanks and love to you both) and the Max Frisch book, by separate mailing in the next day or two. When are you going to Chicago? If I don't speak to you before then, have a good time. I wish I could be there to see the show.[26]

Write, Philip; I'll probably call in a few days or so.

Love to Musa; we sent her a small birthday present, which we're keeping our fingers crossed didn't get lost in the mail.

love,

Ross

September 17, 1978

Dear Ross,

Your thrilling letter came while I was in the center of a very large new painting—great changes again were taking place—pushing me further and further in this uncharted new land—I tore your letter open—and _believe me_—it became more and even more thrilling to read you—while I went on and on with the painting, 'till it really reached its _final_ destination. (Sounds like the "Internationale"—eh?)

What a letter you wrote!—letter—I mean, your mind—your—reactions,—thoughts—well—I can only say—you inspire me—keep me from sleeping, we are two highly charged electronified

[26]Philip Guston: Major Paintings, 1975–76, Alan Frumkin Gallery, Chicago, 1978. [Ed.]

beings, organisms, that keep on exploding or something—We are <u>*necessary absolutely*</u> *to each other, but* <u>*highly*</u> *dangerous—*

[Guston drew a bomb and a "DANGER" sign at this point in the letter—the remainder of which appears in the excerpt preceding Chapter 7, together with Guston's explosive "RANT." According to Feld's notes, in mid-September 1978 he received "a fat envelope inside of which were two paper-clipped and inexactly folded sets of legal pad paper. One set was advertised on the outside back of it as "ROSS—PART I—THE RANT," the other "ROSS—PART II—THE LETTER." Ed.]

———————

Sunday—Sept. 1978

Dear Ross,

Since that somewhat hysterical letter I wrote you a week or more ago, I have been at it—Painting—night after night, I don't know—'round the clock anyway and another image happened for me to see—I don't know what it is—Re-reading your divine letter (the last one) again is even more "thrilling" than it was at first. And I am enclosing some random thoughts—on this sober Sunday morning—I look at the new painting and I write—I* <u>*"think"*</u> *I have painted an image of my tomb—what it will look like. Should I commission a stone cutter to copy it—carve it?*

I will see you very soon.

Love, Philip.

Write soon?

Tell me how the book is. . .

★P.S. Myself talking to myself—of course—as usual. I am circular—like you.[27]

───────

Nov. 13 '78

Dear Ross,

I'm as slow as you are digesting what I read—what I am truly interested in—maybe I am slower. In any case, reading "Motives for Metaphor" many times, thinking about how <u>close</u> it is really, to so many things, we have talked and chewed over, makes me always want to read it again and again.[28] *Of course I relish the way you write—but that's not really it—fond as I am of your startling freshness throughout—you think you have it—and then—watch out—take care—the man—**ROSS** is there to surprise—a new use of a word—even a "street" expression wedged into the "idea" sandwich—so that the article keeps on*

───────

[27]These "random thoughts"—entitled "Thoughts (or Advice to Myself)"—appear as a section preceding Chapter 5. [Ed.]

[28]Feld's piece, written for *Harper's* magazine, was a review-essay of three books of criticism—John Gardner's *On Moral Fiction*, William H. Gass's *The World Within the Word*, and Eudora Welty's *The Eye of the Story*. He concludes that fiction's "most dazzling gift" is the "inspired stumblings" and "accidental splendors" of human imperfection, and that "each one of Welty's essays demonstrates either how vain or how coldly, needlessly ascetic it is to argue for more, as Gardner does, or, like Gass, to bargain for less." [Ed.]

kicking—staying alive—bristles—and conversely, of course, never lies down and behaves like a good article should. A "good" article should "explain" everything in such a way that you can the pile the Mag. on top of others to save for a sit-in day. Or like a college lecture, one makes notes and then goes on to the next lecture. Pass the course. I've heard enough of them to know.

Now Ross, don't you dare put me down as an aesthete. It's, of course, what you say that's important—but how you say it shapes what you say. And it is devastating. The most subtle surgeon in the world could not have made more precise incisions on the different & coarse bodies than you have, on Gardner and Gass. Gardner is easier—like a sitting duck—but Gass, with his pretensions— requires a most delicate set of knives, which you amply have—if not in your pockets, then in your desk drawer. I've read Gass and he has always sounded to me like the best Professors I've run across in English Depts.—lip-smacking, self congratulating profs who just <u>know</u> how everything works. Like master mechanics who can strip a car down to its parts—<u>they know.</u>

I don't know Welty's "Eye of the Story," but you make me so eager to read it. I love everything you say about her and your quotes from her book are so choice. What she says about H[enry] Green—and chiefly about Chekhov—how delicious and true she sounds. I'll run right out and get her book—so much do you make me want to read her! Such a delicate, yet precise piece of an essay (I mean thoughts) you have wrought. But her thoughts— are they not your own thoughts—feelings? They are mine—or close—or I am, feel close to hers. . . "Magic, that will step in and crown art's moment." "The spilled drop, not the saved one."

"*Reflected shimmering fabric.*" How divinely said. It gives me courage; support; to regain my "*failure of nerve*" that attacks me always. I think that because of teaching—having a "career"—being in the "real" world, with dopey minds, who can only "argue for more" or "bargain for less" as you say—that this makes it easier for me to become infected with the linear thinking found in universities—and elsewhere too. I begin to wobble—wonder if I am reaching for the invisible too much—and in tottering like this, I am too prone to settle for "less." And luckily the "less" for me, sticks in my stomach like a sour thing until my "ideal," that I've always had but lose momentarily (could be that one should—needs—to have it slip away—in order to regain it) the "shimmering"—"the dazzling gift." I think you are writing about the <u>generous law</u> that exists in art. A law which can never be given but only found anew each time in the making of the work. It is a law, too, which allows your forms (characters) to spin away, take off, as if they have their own lives to lead—unexpected too—as if you cannot completely control it all. I wonder why we seek this generous law, as I call it. For we do not know how it governs—and under what special conditions it comes into being. I don't think we are permitted to know other than temporarily. A disappearance act. The only problem is how to keep away from the minds that close in and itch (God knows why) to define it.

So—How are you? Work, O.K.? Ellen, busy—thriving? That's how I prefer to picture the both of you. I miss so much not hearing you talk and to talk with. I'm still painting—the forms, the forms, they take off—do strange acrobatics. I can't believe it—my mind tells me not to. I wish I could hide—not hear "art-world"

people talk—but I think I manage to "get back" to where I live. Hope—I pray I am not selling myself a bill of goods.

We've been to Boston and back. No good. No more for another year. When are you coming up? Do you wish to? Would you rather I came in? I hate to have you feel that you should come up—I mean, no need to fulfill a promise naturally. But, if you'd like to—me—Musa—the work—all here—yours.

Write me—do you feel O.K.? I'll come in to see you if you like. I am anxious to hear how the new novel is getting on.

Plum Poems again made its voyage to Boston—Musa takes it with her almost like a talisman. And I read it, too—steadies things at the Ritz.

This is the first time I've painted during the shows I've had. Before, I needed to have my paintings off the walls, in order to start again. They were blushing.

See you soon—

Much love to you & Ellen.

Philip.

———

November 16, 78

Dear Philip,

Mood indigo time around here lately, a combination of deep depression and intense work on my book, both doubtlessly linked to one another. That's why you didn't see me as promised—I'm sorry—nor hear from me.

But I'm much better now. How embarrassing it is to realize how little it takes to move you, as if you lived your life on casters. What I'm trying to do with this book is mute the style very low; it is not easy for me, but it must be done, and it has exhausted me. Exhausted, I feel particularly lonely. Lonely, I feel neglected. Neglected, I get tired again—but all the time working feverishly. But I know I'm on the right track. I know it. I just have to watch myself, keep from either destructively nihilistically saying oh fuck it all—or else becoming too finicky, miniature.

Little things, though: reading Dostoyevsky's notebooks for Crime & Punishment—*very interesting to me, all scumbled and reaching ever nearer to what he knew he wanted and yet didn't know exactly when he had, if that makes any sense.*

The joy, the kicker that knocked me out of gloom completely was getting your letter yesterday. No one has responded to my Harper's *piece as you have—should I be surprised at that?—I guess for a variety of reasons.* Harper's *is a vaguely snotty magazine, you don't expect serious work there, but in this piece I tried very hard to say something that's genuinely important to me—and you alone have truly recognized it. There* is *a "generous law"—so generous that it blankets us and blinds us half the time: it's no damn precise swatch, you can bet on that— but a blanket, or, better, a net. And it is a law—and if it is sometimes comic to obey the law (and when isn't it?) it is just as comic to disobey. The law—from on high—must find it very amusing. Like you say, most minds don't want to know about it at all. They only want to be "right." Being right is the most boring thing in the world to be.*

Ellen has just gone through midterms—grueling exams—and she passed them both. That added to the pressure in the house, so we are now both a little more relaxed—though she immediately had to get right back to work. When I think I'm the tired one, I just have to look at her.

Philip, if it's all right with you and Musa, I'd like to come up on Wednesday, the 29th. Probably in the afternoon: I'd let you know which bus or train, I'd call you a day or two in advance.

Is that all right? I'm very anxious to talk to you, sit and schmooze and really talk, and see the pictures. Wednesday, Nov. 29. Drop me a card, yes or no, then I'll call you. I've started working on notes for the catalogue essay; gonna be good, I think.[29]

Be well, see you soon, E. sends her harried love.

Ross

About a week after Feld's visit on November 29, Guston wrote the long letter—about the three paintings he had just finished in a fury of activity—that Feld chose to use as the opening section of *Guston in Time*. The last few lines of the letter, not included in the excerpt, read as follows:

Ross, can this be? No "art" at all—just the "reality" of feelings, feelings—On and on. I am at the beginning. Now it can pour.

Your visit was a joy—love—

Philip.

[29]Feld had been asked to contribute a lengthy essay to the catalogue for the major retrospective exhibition of Guston's work planned by the San Francisco Museum of Modern Art for 1980. [Ed.]

Feld's next letter to Guston, dated January 22, 1979, consists almost entirely of long quotations from Osip Mandelstam's "Conversation About Dante," written by the poet in 1933, four years before his imprisonment and death at the hands of Stalin. Feld's letter concludes:

> *Christ, Philip, it's thinking too clear and light and hovering almost to be thought!*

The flow of letters then stops and does not resume until July 1979. Guston suffered a near-fatal heart attack in March 1979 and was hospitalized for about a month. It was during this hospitalization that Guston gave Feld a written list of last wishes (Chapter 6) and told his daughter that he wanted three men to say Kaddish for him: "Morton Feldman, Philip Roth, and Ross Feld—the three dearest and deepest friends of his life."[30]

Sat. [7/79]

Dear Ross,

> *Of all the writings on Kafka, a simple statement by Albert Camus always remained the truest and the strongest in my mind. He wrote, "The whole art of Kafka consists in being forced to always re-read his work . . ." etc.*

[30]*Night Studio*, p. 192.

I have read your article at least twenty times over and each time I get new insights—a certain "wit" not easily seen and which fits the context exactly, I think.[31]

It's too good for them—I can see the "professional art eye" bouncing from page to page. But no matter—

I admit that the first and second time I read the piece was out of pure vanity—after all "it was on my work"—But then after and more strongly this morning I read it detachedly—for itself. And I want to put it in writing to you—it is truly wonderful, subtle, & surprising!

I admire and [am] most moved by many parts (tell you when I see you). In particular the sense you have of the "mixture" of feelings contained in the work—even the mixture in a single painting. And how you can express this! Your sense of the comic in my work makes me weep.

Your sense that the 50's work and early 60's—was "<u>forced</u>" to "<u>look</u>" "abstract" was the largest part of the comic-absurd subject. I knew it at the time but couldn't tell anyone.

I hope your piercing look at me doesn't make me want to hide—stop painting. I have never experienced anything like this—I've always felt—the further away, the better. But don't worry—like the simple word FINIS at the end of a great Fellini film, means not FINIS—but more to do, more to go on, still.

So, this is a heart-felt word of many gratitudes to you. It is the event of my life.

[31]The "article" was apparently an early draft of Feld's essay for the SFMOMA exhibition catalogue book. [Ed.]

The word FINIS really means that things are beginning to be understood. And one's greatest desire finally is not to be merely liked, etc., but to be <u>understood</u>.

Let's see you soon—

love Philip.

———————

9/20/79

Dear Philip,

Perhaps <u>Reverse</u> is inadequate.[32] To me, who hasn't been able to take my eyes off it since it arrived yesterday afternoon, who has been sucked into it for an hour at a time, Universe seems more appropriate.

The shattering of images: that we <u>always</u> enter reality backward. The old rationalist rebutttal to empiricism—do you stick a foot out to test, upon entering a room, to see if the floor's there?—here finds its answer. No, you don't, but you do instead walk in facing the other way. The terrifying fact isn't that there is not a floor—but that there <u>is</u>, always.

Our condition of floorlessness is ever stymied. Depending on your humors, this is either known as reality or tragedy.

The four triangles at the corners, all different, all of use—but exactly how? Stress seems to pull and push <u>within</u> them—there

————————

[32]Guston had given the Felds a painting with this title. It is a vertical work showing the reverse side of a canvas, with painting-stretcher supports and corner blocks, and the chain of a light-pull hanging down. [Ed.]

is a tension of the unseen, of the capped and hidden. If I wake up one morning to find one of them shot from the frame, will I be surprised?

The stretcher's sea-worthiness, its roll—with the nailheads, so subtly random yet appearing somewhat regular: like atoms!

The cloud formation, the increment of vapors, almost, within the four squares made by the wooden braces: do you have to see a front when a back gives this much information?

And, not clear to me before, and I risk sounding mystical and synesthetic here—but the light bulbs, God damn it, have a <u>sound</u> to them, I swear. They are your bells. They clap a knell—or they freeze on the verge of.

Oh, I don't know, Philip, it is so great and bountiful and mysterious a work, I don't know how I will live with it except to be changed by it—and that little Rilkean strategy has been in effect ever since I first came across your work years back. Now it'll be in spades.

Ellen gets chills, that exaltation-tickle, looking at it, in love with its absoluteness—but, I, ah, I'm the one who sees a bit more because I'm more familiar—and at the very point at which I seem to corral it, it wriggles free.

It is, plainly, Philip, an addition to my life, larger-dosed in pleasure and mystery and thought and sufficiency than almost anything else planted into my days ever.

What else is real but art, said the slave to the whipmaster, eh? So excuse this ecstatic burble, take it for what it [is], gratitude grained a little too deep to be merely polite and unexcessive.

Thank you, Philip. We are in love with Reverse and happily unfree.

Ross

———

Sat. [circa September 1979]

Dear Ross,

I don't—can't—write letters anymore—am writing this one in blood. Your letter first made me tremble, then, powerful, uncontrollable shaking came over me—like a Los Angeles earthquake I experienced as a boy way back. I have never in my life experienced a <u>living</u> seismograph actually recording every tremor, every nerve end. What is really the miracle is that <u>all</u> you say—every word, matches my own sensations and thoughts.

I'll <u>say</u> it!—You are Valéry—Proust, and I <u>must</u> be Cezanne. Your thoughts are the only things that has happened to me this year of any import. I'll shout it right out—you inspire me to paint again! To get out of my circular brooding, my dwelling on my ills and crotchets.

I was quietly looking at "Reverse" before the men picked it up and I was thinking about the light—the hidden hilation behind the stretcher—You're so exact—of course, the mystery is all behind, the part you don't see, but know about. A key word in your letter is KNELL—of course! And I was having a queer feeling that the <u>angle</u>—the tilt—of the light chain on top changes

the image or dissolves the canvas image into a total sound instead of mere image making—a sound almost of a subdued clanking, a leverage, which changes wood of stretcher into what? Surely something else, than what seemingly is being represented. As if something is being moved—an unidentifiable force outside the image is changing everything into God knows what.

Believe me, it is not only the lightbulb <u>but together</u> with the angular tilt of the chain that gives the sensation of "knell." In a way the stretcher is a kind of prop, like a stage prop being gently tugged, being moved slowly away, but stopped at this moment of being moved SO WE CAN SEE IT: I sensed the sound of iron.

My God what a mystery image making is! The potency to change—to metamorphose into an otherness that we don't know—haven't known—yet—until we see it—there—. The image is in a KIND OF WAREHOUSE? [the word "wherehouse" is crossed out. Ed.] *pulleys—levers—and such are at work. No wonder "Thou shall not make graven images"—the God of Moses knew what he was saying.*

I hope (I know) the painting <u>keeps on</u> changing for you—It has changed me—I demand it of what I do—I test it this way—not always succeeding—at times I like to play, have fun, not be so damn bare-bones serious—(human—only too human)—but down deep I hunger for the other power—that which keeps on reverberating. It lasts.

YET BE PREPARED! THERE WILL BE TIMES WHEN THE PICTURE WILL APPEAR AS A MERE NOTHING. AS IT SHOULD BE.

Musa (my wife) thought I talked you and Ellen into it. But Musa (my wife) thinks I talk too much anyway—that I interfere. Well, I keep on training her. But it is an even exchange—her doubt feeds me. Later she changes and sees what she didn't see before and in turn makes me see what I hadn't before. How lucky I am.

I can't wait to see you in the city—we are coming down Wed. Oct. 3 to Mayfair House on Park. Taxied down sometime late P.M. I'll call you right off, naturally.

All our love to you both—

Philip.

1/16/80

Dear Philip,

Isolation has its enchantments. <u>No world out there? Good, that's how I always wanted it anyway.</u> Bit dangerous, of course; I understand now the Guston shut-the-phone-off switch. Now I'm <u>pupik</u>-deep in my novel, and in the last week especially it has begun to come fast, but <u>really</u> fast. Everything else has been sacrificed. (Isaac was just lucky his father was Abraham, not Ross. Ross would have lowered the blade despite the last-minute God-reprieve. Ross has discovered himself to be an avid sacrificer indeed.) And but for <u>Kirkus,</u> my financial link to the "world" (you remember the world, Philip, that round thing with all the farshtunks holding on), I'm hardly leaving the

house. A chapter-end looms, though, and that promises a hiatus. I can't figure out whether hiatus is time's grace or its punishment; what looked so good in the doing looks so terrible in the done.

I lied: I did have to go out, to Braziller.[33] What I'm about to relate must be taken in the spirit in which it was enacted: farce. After all the last-minute hysterics about the four pages to be killed, and then the reprieve, it turns out that twenty lines of my essay had to be cut out nonetheless—space limitations. It ran too long. This was acceptable to me, something I understand. And even though our gal Tish didn't tell me that the lines had been cut till after the fact, this still was O.K.; in fact, she did a good job of cutting if cutting she had to do. Most of what was taken out was in the biographical section, and was fairly inoffensive to me.

Enter farce. Certain changes that I'd only asked to be made _five_ times remained unmade. Ask a sixth—do not be proud. Certain things settled upon suddenly became unsettled. The gems of these was a change in repros of Rimbaud "sanguinous" vision to Rimbaud's "sanguine" vision. Bloody to cheerful—but what the hell, right? Brought to her attention, this discrepancy sent our gal Tish to the dictionary, which a second later she closed with the admission, "Well, I guess I learned something."

[33]George Braziller, the New York publisher, in association with SFMOMA, published the catalogue book for the 1980 restrospective exhibition. Feld's 25-page essay was the principal text. [Ed.]

Act II. One of the changes I asked made was a matter of two ungrammatical sentences, sentences I wanted left as fragments. This led to words. This led to shouts. This led to our gal Tish declaring that Mr. Braziller would have to settle this stylistic point. Enter Braziller, who reads the sentences in question for twenty minutes, it seemed, then looked up. "Uh, uh, well, I'm not exactly clear what you're trying to say in the entire paragraph. What's this mean?"

Ross: "It refers back to an earlier paragraph. Really, it's O.K. Let's get back to these changes I want made. I'd like to establish a step-down effect, a cascade after an italicized verb, therefore relinquishing the other verbs in the two succeeding fragments. Do you see?"

Braziller: "You know what? Let's call in Hal" (someone brand-new to me). "Hal will be able to know if this is good or not. Hal is a writer. He writes for Artforum all the time."

Ross: stifles groans. Artforum!

Enter Hal. "Hello, hello, what seems to be the trouble here? Hmm. Hmm. I don't understand something. What does 'mouth of a cannon' have to do with Guston?" Then this latest Solomon exeunts.

Ross controls himself. The other changes are gone through. Braziller, having garnered no rescue from Hal of Artforum, finds the ball in his court again. "Well, Tish," he spake, "if he" (he is me) "if he wants it that badly, just give it to him."

So they gave it to him.

Publishers! No wonder writers are such churls, such acerbs.

The reason, though, that you did not read in today's paper the grisly unfortunateness of young blond art editor strangled, body found with legs sticking up in Park Avenue trashcan, is that our gal Tish had the presence of mind to forestall her murder by showing me, after we were all done, the designed book, all pasted-up except for the color plates. I duly melted. Philip, it is a beautiful thing indeed; you will more than [be] pleased, you will marvel. Our gal Tish also tells me that the book will be on press next month, which is great.

Thus my adventures in the world where they wear ties and go out for lunch.

How is your world coming? As my book starts rolling down the hill I'm beginning to get antsy (why are we never ever satisfied?) and have decided to keep a journal. The journal lies empty. Just so much writing can I do, complains the writer. But the journal waits, accumulating my guilt. Maybe I'll open it to find it completely filled!

Ellen has now begun to study physical diagnosis—i.e., how to examine a patient. She sits for two hours listening to my heart with her stethoscope while I read. This is something we must have cribbed from an Ionesco play.

How are you both? Not much snow here, so probably a little more but not all that much more there? Are you working? I long to see the new pictures so, and to talk to you. At the moment, the fingers go automatically anyway, so I thought: a letter. Write one too.

Be well, both of you. E. sends her most enormous love.
love, from "he" to whom it was given, who
wanted it that badly,

Ross

The Gustons attended the opening of the retrospective at the San Francisco Museum of Modern Art in May of 1980 and sent the Felds a postcard soon after their return.

May 27, 1980

Dear Ellen & Ross,

Getting your wire in S.F. was like being <u>HOME!</u> They say the show is fine—I wouldn't know being in a daze. Back now, picking up the pieces of ourselves—See you soon? Hope all is well with both of you. All love—

Musa & Philip.

Philip Guston died on June 7, 1980, in Woodstock, New York.

EDITORS' NOTE

Ross Feld completed the manuscript of *Guston in Time* in the fall of 2000 and asked several of Philip Guston's friends and associates to review it for factual accuracy. Before his death in May 2001, however, Feld did not have an opportunity to revisit the text of *Guston in Time*. The editors gratefully acknowledge the generous assistance of Musa Mayer, David McKee, Archie Rand, Ellen Feld, and Larry Merrill in sharing their knowledge of Philip Guston and Ross Feld (and in making available Feld's notes and previous writings on Guston), so that the handful of final revisions that Feld contemplated could be completed. Jan C. Grossman and Herbert Leibowitz also provided invaluable advice and assistance in the preparation of this book.

IMAGE CREDITS

All Philip Guston paintings are copyright © by the Estate of Philip Guston and appear here courtesy of the Estate of Philip Guston and Hauser & Wirth.

Pit, 1976; National Gallery of Australia, Canberra, purchased 1980. Photograph: National Gallery of Australia, Canberra.

For M., 1955; San Francisco Museum of Modern Art; anonymous gift, Los Angeles. Photograph: Ben Blackwell.

Source, 1976; The Museum of Modern Art, New York. Gift of Edward R. Broida in honor of Uncle Sidney Feldman. Photograph: © The Museum of Modern Art / Licensed by SCALA / Art Resource, NY.

Web, 1975; The Museum of Modern Art, New York. Gift of Edward R. Broida. Photograph: © The Museum of Modern Art / Licensed by SCALA / Art Resource, NY.

Wharf, 1976; Modern Art Museum of Fort Worth, purchase, the Friends of Art Endowment Fund. Photograph: Modern Art Museum of Fort Worth.

Cherries, 1976; The Museum of Modern Art, New York. Gift of Edward R. Broida in honor of Glenn D. Lowry. Photograph: © The

Museum of Modern Art / Licensed by SCALA / Art Resource, NY.

Blue Light, 1975; San Francisco Museum of Modern Art; purchase through the Helen Crocker Russell and William H. and Ethel W. Crocker Family Funds, the Mrs. Ferdinand C. Smith Fund and the Paul L. Wattis Special Fund. Photograph: Ben Blackwell.

Talking, 1979; The Museum of Modern Art, New York. Gift of Edward R. Broida. Photograph: © The Museum of Modern Art / Licensed by SCALA / Art Resource, NY.

Head and Bottle, 1975; private collection, New York. Photograph: Courtesy of the Estate of Philip Guston.

Group in Sea, 1979; private collection, New York. Photograph: Courtesy of the Estate of Philip Guston.

Friend – To M.F., 1978; Des Moines Art Center. Purchased with funds from the Coffin Fine Arts Trust; Nathan Emory Coffin Collection of the Des Moines Art Center. Photograph: Rich Sanders, Des Moines.

Untitled, 1980; private collection. Photograph: Genevieve Hanson.

Edge of Town, 1969; The Museum of Modern Art, New York. Gift of Edward R. Broida. Photograph: © The Museum of Modern Art / Licensed by SCALA / Art Resource, NY.

Ladder, 1978; National Gallery of Art, Washington. Gift of Edward R. Broida. Photograph: National Gallery of Art, Washington, DC.

Green Rug, 1976; The Museum of Modern Art, New York. Gift of Edward R. Broida in honor of Ann Temkin. Photograph: © The Museum of Modern Art / Licensed by SCALA / Art Resource, NY.

Monument, 1976, Tate, London. Purchased with assistance from the American Fund for the Tate Gallery, 1991. Photograph: © Tate, London / Art Resource, NY.

Michelangelo Buonarroti, *The Conversion of St. Paul*; Vatican Palace, Rome.

OTHER NEW YORK REVIEW CLASSICS

For a complete list of titles, visit www.nyrb.com.